GEMÄLDEGALERIE

Berlin

50 Masterpieces

Hans Holbein the Younger, *The Merchant Georg Gisze* (detail)

GEMÄLDEGALERIE

Berlin

50 Masterpieces

Edited by
Jan Kelch and
Rainald Grosshans

SCALA

© 2001 Ernst Wasmuth Verlag Tübingen·Berlin and Scala Publishers Ltd

First Edition: Scala Publishers Ltd, 2001
Fourth Floor, Gloucester Mansions
140a Shaftesbury Avenue
London WC2H 8HD
England

Reprinted 2002

In co-operation with Ernst Wasmuth Verlag
Fürststrasse 133
D-72072 Tübingen
Germany

ISBN I 85759 254 9

The texts were written by the following authors:
Roberto Contini (R.C.)
Rainald Grosshans (R.G.)
Jan Kelch (J.K.)
Rainer Michaelis (R.M.)
Hannelore Nützmann (H.N.)

Editing of the German edition: Rainald Grosshans
Translation: Martin Chalmers
Editing of the English edition: Slaney Begley
Design: Anikst Design

Photographs: Jörg P. Anders, Berlin
Interior and exterior photographs of the gallery: Stefan Müller, Berlin
Printed in Italy

Cover: Petrus Christus, *Portrait of a Young Lady* (detail), *c.*1470

Contents

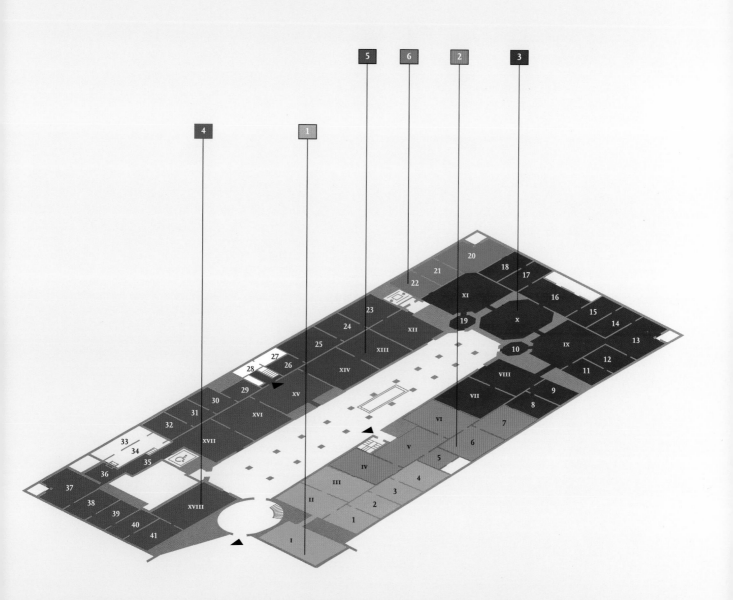

| 5 | 6 | 2 | 3 |

| 4 | 1 |

20
21
22
18
17
XI
16
23
XII
19
X
24
15
25
XIII
14
27
26
XIV
9
10
IX
13
28
29
30
XV
VIII
12
31
XVI
VII
11
32
VI
8
33
XVII
7
34
v
6
35
5
36
IV
5
4
37
III
3
38
II
2
39
XVIII
1
40
41
I

The new Gemäldegalerie from the south-east with the Villa Parey

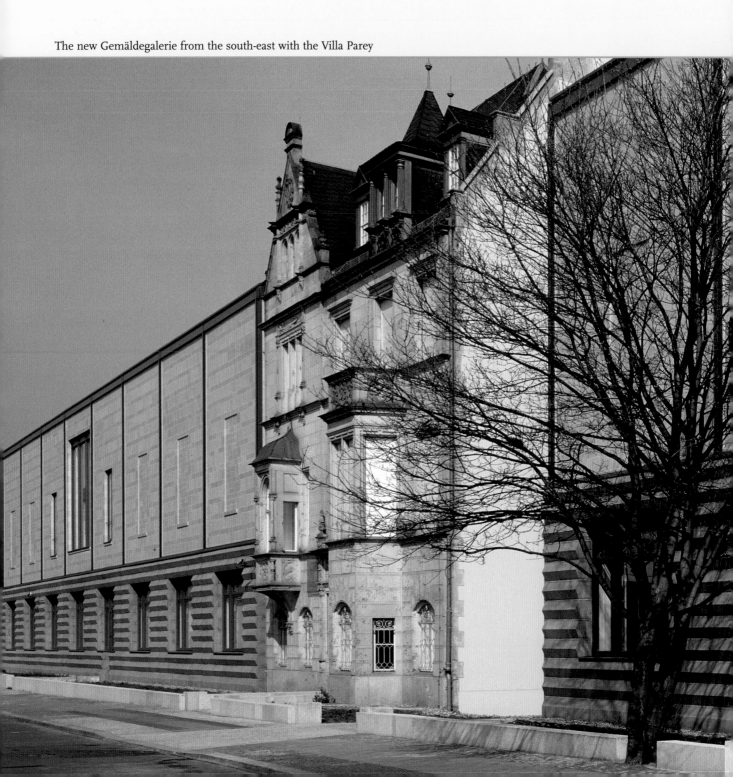

View of the new Gemäldegalerie from the Nationalgalerie

The paintings presented here are well known – thousands have seen the originals and many more have studied them through reproductions in publications other than this. They are just some of the highlights of the Berlin Gemäldegalerie, one of the leading centres of its kind and home to six centuries of European painting. The oldest items in the museum are precious altar panels dating from the Late Middle Ages, and the collection holds examples of all the schools and styles of European painting from this period to the conclusion of the Baroque tradition towards the end of the 18th century. The abundance of masterpieces in the collection can only be truly appreciated by visiting the Gemäldegalerie itself, and it is hoped that the colour plates and expert commentaries included in this volume will encourage the reader to make just such a trip.

The Gallery only regained its traditional all-round character in 1998, when its new home was opened in the Berlin Kulturforum. Paintings in the collection that survived the Second World War were subsequently divided between the Kaiser Friedrich Museum (which since 1956 has been known as the Bode Museum) in the Eastern half of the city and the Museum Dahlem in the West. Today, they can be seen once more as an undivided whole, reflecting a particular tradition that was founded on the ideas of the Enlightenment, but above all on Romanticism's understanding of art. 'First give pleasure, then instruction' was the principle that had been purposefully realised by the intellectual parents of the first public museum in Berlin. When the Gallery opened in 1830 in the Alte (Old) Museum designed by Karl Friedrich Schinkel, it did indeed offer the visitor both beauty and a systematic view of art history, masterpieces of the first rank, but also an arrangement of the exhibits aimed at instructive comprehensiveness.

From the very beginning the Gallery was of the first rank, a position it owed to the patronage of Friedrich Wilhelm III of Prussia, who in 1815 in Paris had acquired a group of 157 paintings from the former Giustiniani Collection. This brought major works of the Italian early Baroque to Berlin. In 1821 this was followed by the purchase of the Edward Solly Collection of 3,000 pictures. Solly's main interest had been in Italian painting and he had collected early examples of the genre as well as classic works. These large-scale purchases did not enter the Gallery in their

The glass ceiling of a top light room in the new Gemäldegalerie

entirety – the paintings were first critically appraised by the so-called Installation Committee, presided over by Gustav Friedrich Waagen. Individual acquisitions, too, had to satisfy the declared aim of contributing to the systematic representation of art history. This remained the case even for those pictures that had been selected from royal property. In the inaugural inventory of the gallery, which comprised 1,198 pictures, the 'royal share' amounted to barely a quarter. Waagen was appointed the first director of the Gallery and, despite a low budget, significant purchases were made during his occupation of the post. However, the Gallery owes its expansion in every area and its worldwide reputation to Wilhelm von Bode (1845–1929) who entered the service of the Berlin Museums in 1872. Like Waagen, he was an outstanding art historian, but also an organiser, who was able to take advantage of the changed cultural and political conditions of the age with energy and cool reason. With the establishment of the German Empire (1871) and of Berlin as the imperial capital, the Gallery now had the further duty of reflecting the nation's new increase in power. Funds flowed in abundance and

Bode went on a shopping spree. He did not simply add to the collection, however, but acquired paintings that both created new emphases and consolidated existing strengths – for example the Rubens and Rembrandt groups.

The rapid growth of the Gallery made the building of a new, larger building necessary. In 1904 the Kaiser Friedrich Museum, designed by Ernst Eberhard von Ihne, was opened at the northern tip of Museum Island. The move to this building, which was followed in 1930 by an extension in the north wing of the Pergamon Museum, was one of the happiest periods in the history of the Gallery, which by now had a stock of 3,600 pictures and had attained an unusual degree of comprehensiveness. The First World War and, to a greater extent, the Second World War interrupted this brilliant development. The year 1945 saw the collection, which had previously been evacuated, scattered and suffer considerable

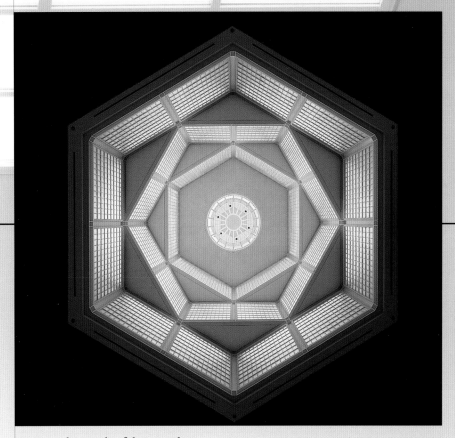

View into the cupola of the rotunda

losses. The political division of the country and of the city of Berlin in 1948 led finally also to a division of the stock between East and West – a situation that was to endure for half a century.

What has now been brought together under one roof are parts of a collection that developed coherently and that, when reunited, regained a special character. The new Gallery building, designed by Heinz Hilmer and Christoph Sattler, underlines the importance of the collection. It also responds to the needs of visitors. The large central hall, which is subdivided by two rows of pillars, is an ideal space for people to meet and relax. Clear glass cupolas above the flat ceiling curves allow daylight to flood this area, casting ever-changing shadows throughout the day.

The Flemish painting section with a triptych by Jean Bellegambe

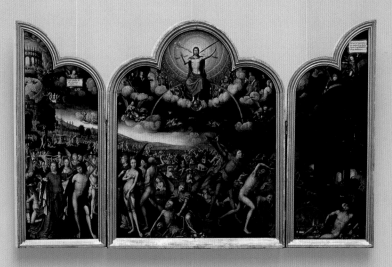

View of the Ricci staircase

The rows of polygonal high-grade steel rods installed in a shallow basin, the *5-7-9 Series* by the concept artist Walter de Maria, also emphasise the hall's designation as a place of contemplation.

The exhibition rooms themselves are arranged in a horseshoe around the hall – as a double row moving from the inside to the outside and divided into rooms and cabinets – and also receive daylight from above. Here, however, the light is filtered and then spread uniformly. A floor of smoked oak and a wall-covering of light-absorbent velvet also help to dampen distracting reflexes. These measures have helped to give the impression that the paintings alone catch the light, thus revealing the full luminosity of their colours.

The disposition of the exhibition rooms on three sides of the hall enables both a topographical and chronological organisation of the exhibits according to schools north and south of the Alps, linked by the section at the head of the hall, to which is assigned paintings of the 17th and 18th centuries in the Netherlands, Germany, France and England. The strict art-historical arrangement of the pictures initiated by Waagen in the Alte Museum and then adopted by Bode in the Kaiser Friedrich Museum has basically been retained. In order to display the individual artworks to best advantage, however, it was decided to avoid a multi-storey presentation. The pictures simply hang next to one another. Sometimes, to point up individual works, the sequence is asymmetrical. There is no sense of monotony with this arrangement, however, since in the succession of rooms changing proportions and sight axes emerge. A more closely packed presentation would impair the delicate rhythm.

Only about 1,150 paintings could go on show in the main gallery and consequently a rigorous selection had to be made from the collection of almost 3,000 works. This is nothing new: the overcrowded upper floor of the Bode Museum only held 400 pictures, while the Dahlem Museum displayed 700 paintings. Measured against the Alte Museum, the original home of the Gallery, and its subsequent

Rembrandt Room

domicile of the Bode Museum, the Gemäldegalerie is today housed in the largest building in its history. A study gallery on the ground floor provides hanging space for further works in the collection, and many of the pictures that have a place there are the equals of the treasures in the main display rooms. In a collection such as this, which has been carefully developed according to scholarly criteria for almost 200 years, it is rare for a work not to have earned its place. The Gemäldegalerie's new home has just been opened, and it would be both immodest and unrealistic to suggest a speedy expansion of the available space in order to encompass what is actually available for display. In any case, in view of the war and post-war years, the pictures and their public should first of all be granted the time and the peace to become acquainted again.

Jan Kelch
Director of the Gemäldegalerie
Staatliche Museen zu Berlin

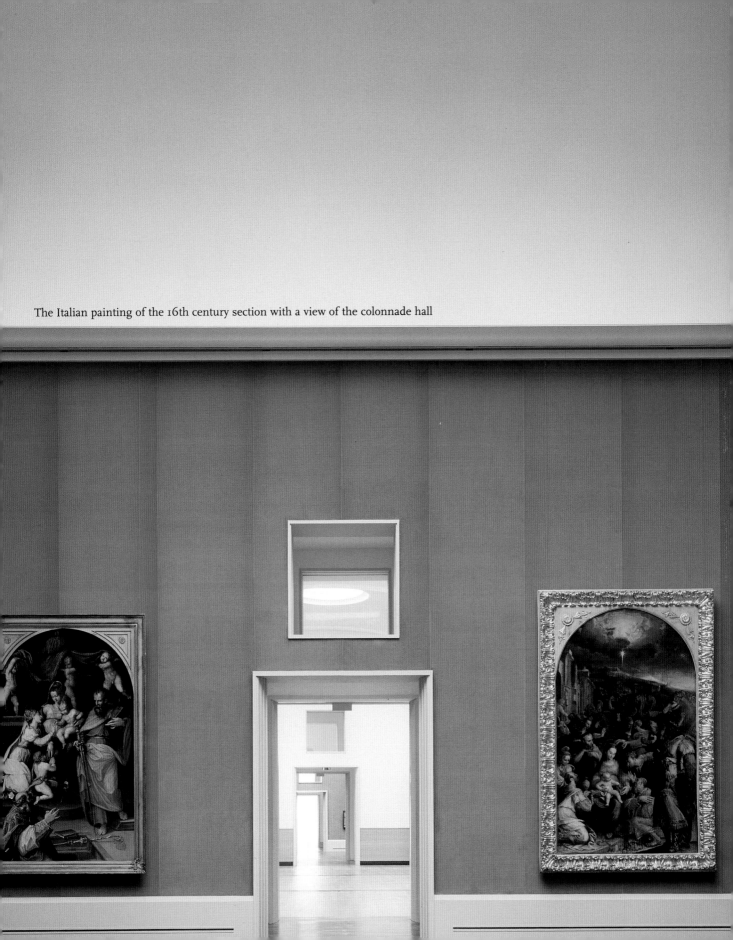

The Italian painting of the 16th century section with a view of the colonnade hall

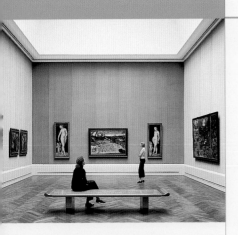

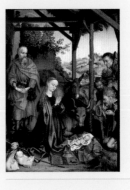

Room 1

WESTPHALIAN. AFTER 1250

HANS MULTSCHER

MARTIN SCHONGAUER

ALBRECHT DÜRER

HANS BALDUNG, KNOWN AS GRIEN

LUCAS CRANACH THE ELDER

HANS HOLBEIN THE YOUNGER

Room 1

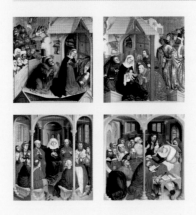

Room 1

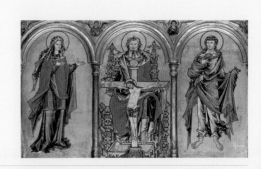

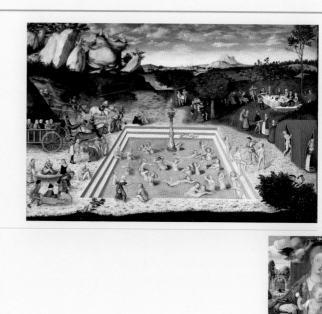

Room III

Room 2

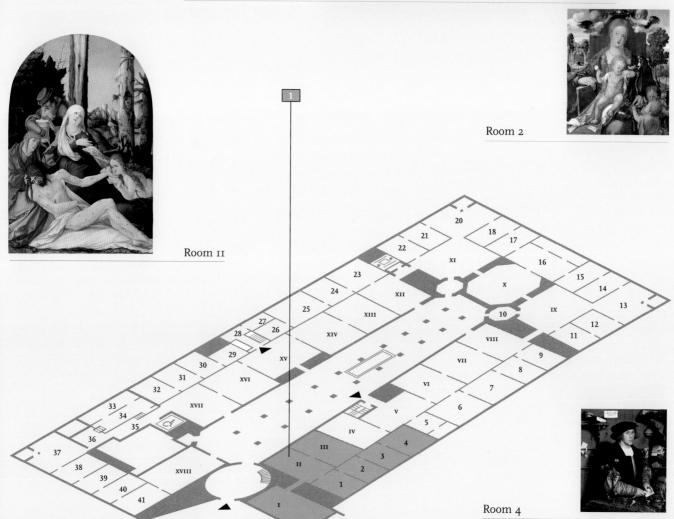

Room II

Room 4

1

20
21 18 17
22 XI 16
23 X 15
24 14
25 XII 13
27 26 XIII IX
28 XIV 12
29 X 10 11
30 XV VIII
31 9
32 XVI VII 8
33 VI 7
34 6
35 XVII V
36 IV 5
37 III 4
38 XVIII II 3
39 I 2
40 1
41

Westphalian. After 1250

The altarpiece from Westphalia in north-western Germany was painted during the closing years of the Hohenstaufen family's rule of the Holy Roman Empire (1138–1254). The break with Byzantine art also coincided with the end of this dynasty and the subsequent interregnum (1256–73). The altarpiece can be assigned to this transitional period. The picture area is divided into three panels of equal size by arches and half-columns. The mounted arcades of the frame, the clear contours of the figures, the gold background and the brilliant colours are reminiscent of reliquaries and precious retables worked in brightly-coloured enamels and gold. In their abstract exaggeration, the sharply pointed folds of the clothes are typical of the late phase of the pointed style and therefore of the conclusion of the Byzantine-influenced tendency within painting. The middle panel shows God the Father on his throne. In his hands he holds the cross with the body of his sacrificed son. Above, there hovers the dove of the Holy Spirit. The cross grows out of the earth, alluding to the double nature of Christ, who is both man and god. Standing in the side panels are the Virgin Mary and St John the Baptist, who appear as intercessors for humankind. The representation of the Holy Trinity in the form of the 'mercy seat' illustrates the sacrifice of the Son of God, in which, constantly renewed, God's mercy is revealed.
R.G.

Westphalian. After 1250
Altarpiece with the Mercy Seat
Oak panel, 71 × 120 cm
Acquired 1862
Cat. no. 1216B

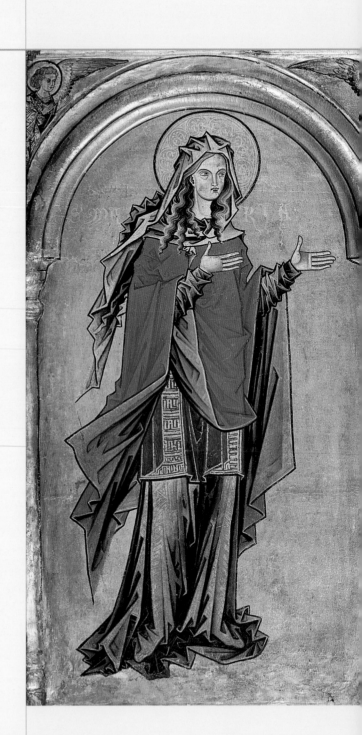

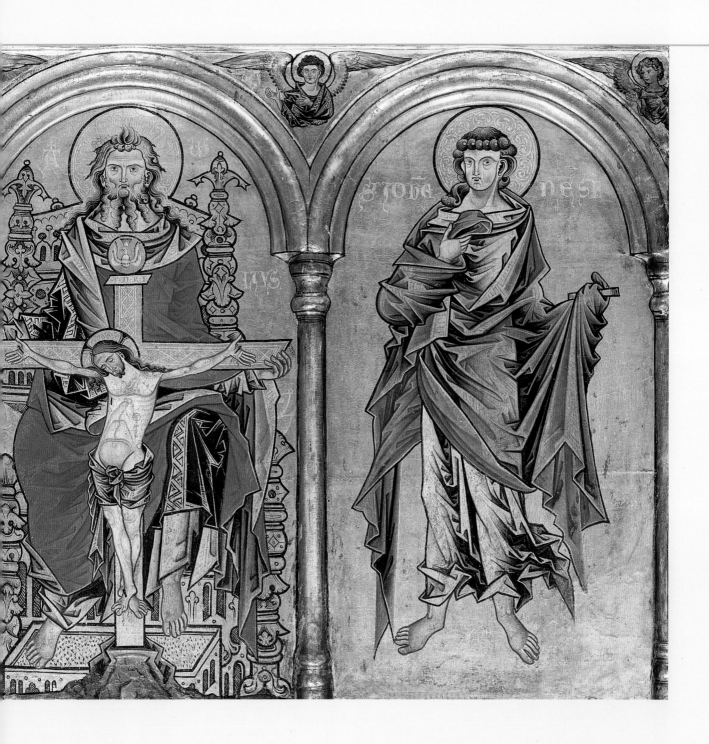

Hans Multscher, *The Wings of the Wurzach Altar (Four Scenes of Christ's Passion)*, 1437

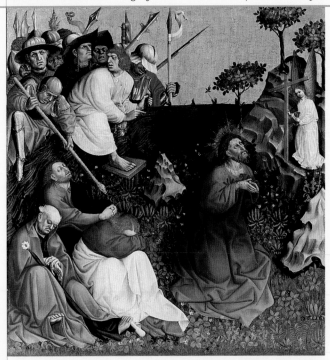
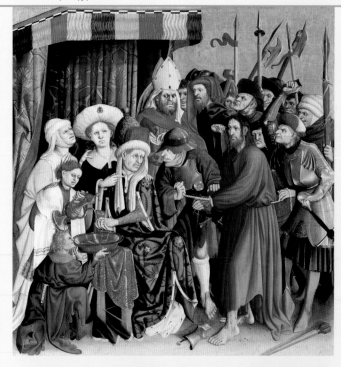
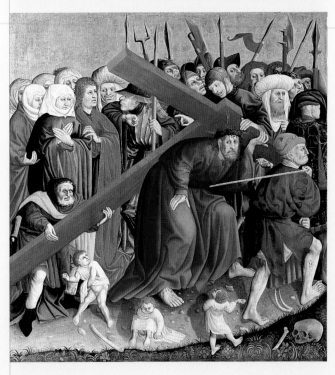
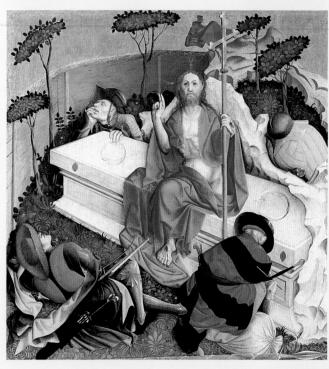

Hans Multscher, *The Wings of the Wurzach Altar (Four Scenes of the Life of the Virgin)*, 1437

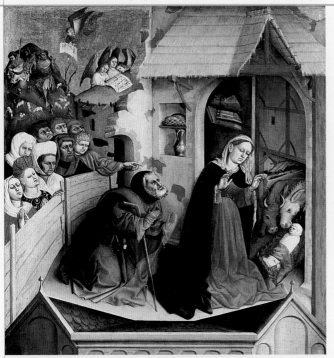
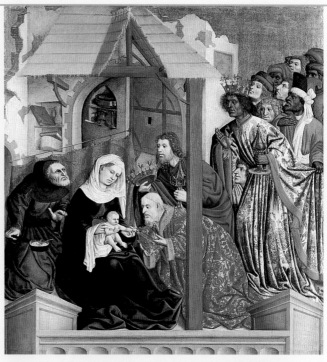
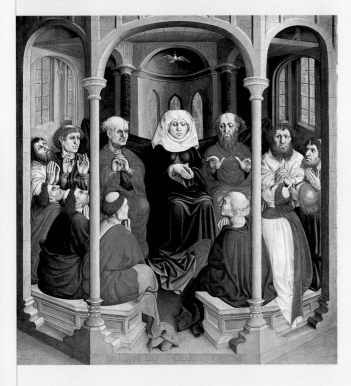
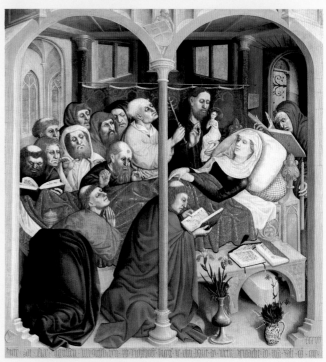

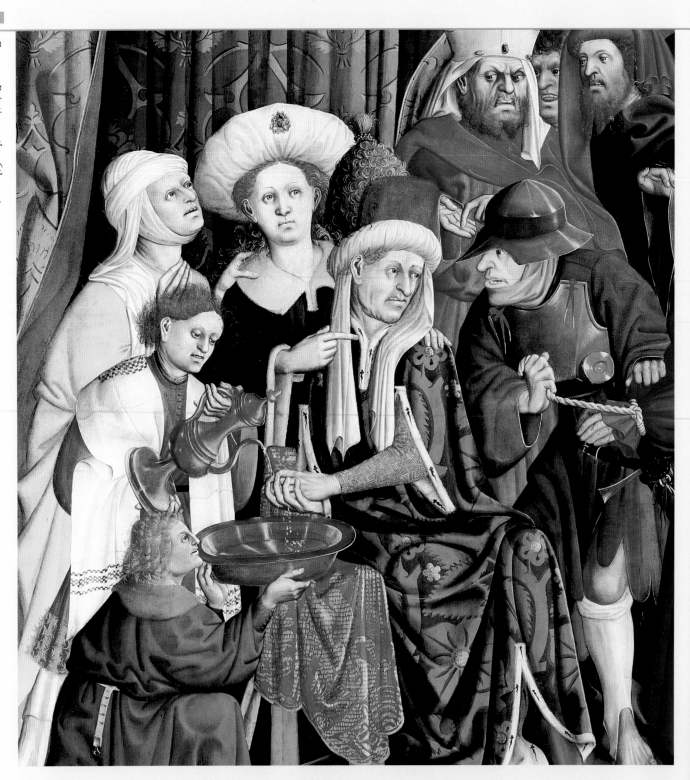

Hans Multscher

The wings of the Wurzach Altar by Hans Multscher are among the most important 15th-century German paintings. In the 18th century they formed part of the art collection of the Count of Waldburg Zeil in Schloss Wurzach in Upper Swabia, a provenance that is still reflected in their name today – the Wurzach Altar. Each wing shows two scenes each from Christ's Passion and from the life of the Virgin, both placed one above the other. The events of the salvation story are depicted in chronological order. In all likelihood the fronts of the wings were also painted with scenes from the Passion. The sequence opens with Christ's prayer on the Mount of Olives. This is followed by Christ before Pilate. The Roman procurator has just pronounced the death sentence and is washing his hands as a sign that he is innocent of the death of the Lord. The next scene is of Christ carrying the cross to Calvary. The sequence concludes with Christ's resurrection. The scenes from the life of the Virgin, depicted on the inner sides of the wings, begin with the birth of Christ. Mary and Joseph worship the child in the stable, while outside in the fields angels announce the birth of the Lord to the shepherds. Full of curiosity, a crowd of men and women look on from behind the wooden fence of the stable. The next scene shows the adoration of the Three Wise Men who had followed the star to offer the child gold, frankincense and myrrh. The third scene, the Feast of Pentecost, shows the Virgin and the Apostles in a chapel-like room. Above them is suspended the dove of the Holy Spirit, which is poured out over the faithful. The final picture is of the death of the Virgin. Christ stands at her deathbed and has taken his mother's soul, in the shape of a tiny girl, into his arms.
R.G.

Hans Multscher
(c.1400–before 1467)
The Wings of the Wurzach Altar,
1437
Canvas on pine panel,
each 150 × 140 cm
Acquired as a gift from Sir Julius
Wernher, 1900
Cat. no. 1621, 1621A-G

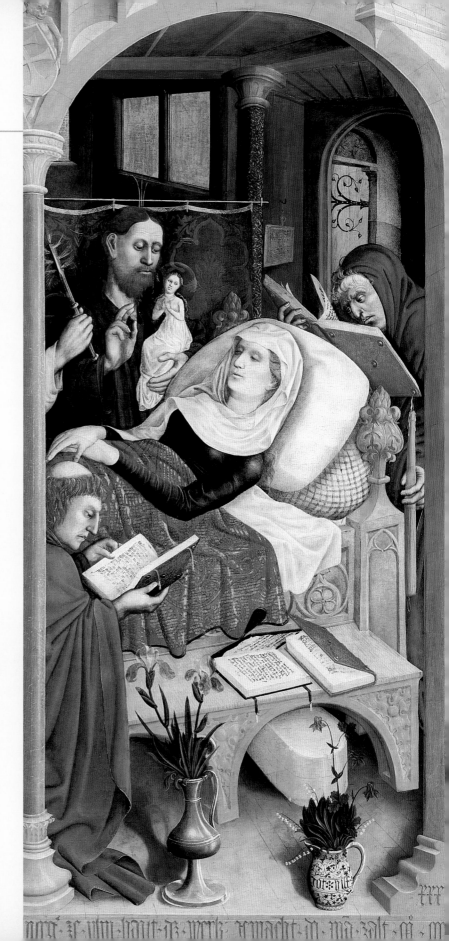

Martin Schongauer

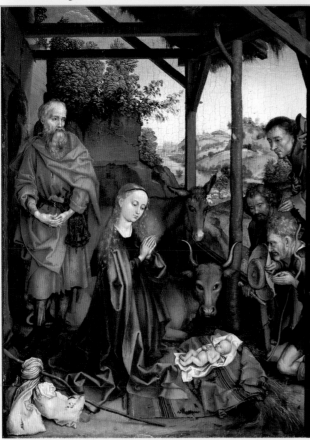

Martin Schongauer
(*c.*1445–91)
*The Birth of Christ, c.*1480
Oak panel, 37.5 × 28 cm
Acquired 1902
Property of the Kaiser
Friedrich Museum Society
Cat. no. 1629

During the Reformation iconoclasts destroyed many of Schongauer's works, hence the quantity of paintings ascribed to him is small. Only a dozen of his paintings are known to have survived, including this small nativity scene, painted around 1480. It is one of the most mature and beautiful works of the master who was born and lived in Colmar in Alsace. He was referred to as 'Martin the Beautiful' or 'Martin the Handsome' by his contemporaries, who held his art in high regard.

The Birth of Christ is set in a stable, which consists of a few beams and a leaking roof leaning against a dilapidated building. Between the supporting beams the view opens out on to a green summery expanse of rolling hills, with a river or a lake and a town in the distance. The focal point of the painting is the Christ child, lying naked on some swaddling clothes and a torn blanket spread over a bundle of straw on the ground. Mary is kneeling next to the child, her hands folded in prayer. Joseph stands close behind her. His gaze is directed at the shepherds who have hurried in from the right (the angel of the Lord having announced the birth of Christ to them in the fields). The oldest shepherd, who has grey hair, kneels close to the child. He is followed by a somewhat younger man with a straw hat and a flute in his hands. The third shepherd is standing, slightly bent forward, holding in one hand the horn with which he calls his cattle and his dogs. Between these two groups we see the ox and the ass who, according to tradition, shared the stable with the Holy Family. The ox is very close to the newborn child and keeps him warm with its breath. The animal looks out of the painting with large, dark eyes. The ass is further in the background. This is an allusion to the symbolism which saw the ox and the ass as embodiments of the Old and the New Testament respectively. This beautiful painting gently draws the observer in, giving him or her the feeling of being present at the event. This, and the luminous intensity of the enamel-like colours, contributes considerably to its credibility and immediacy.
R.G

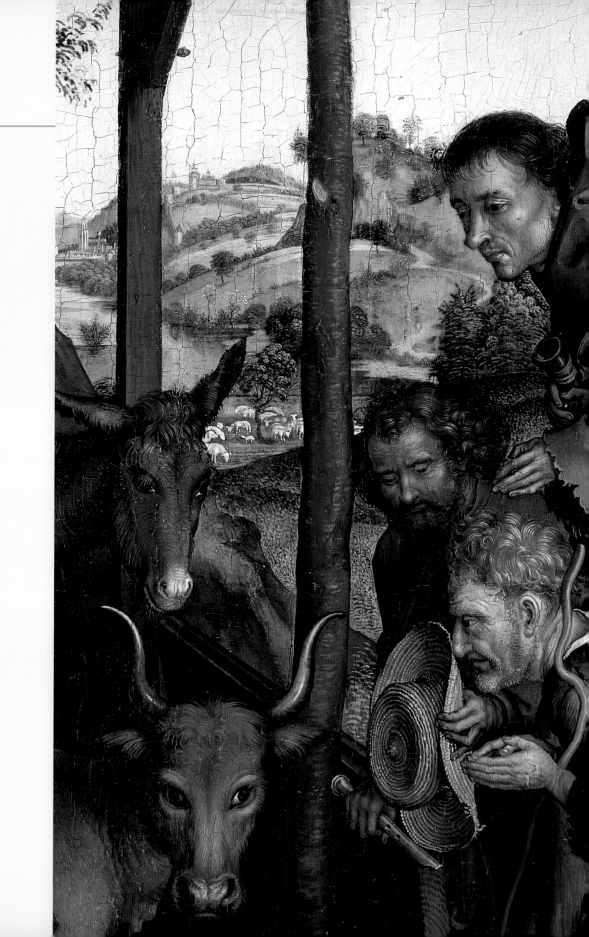

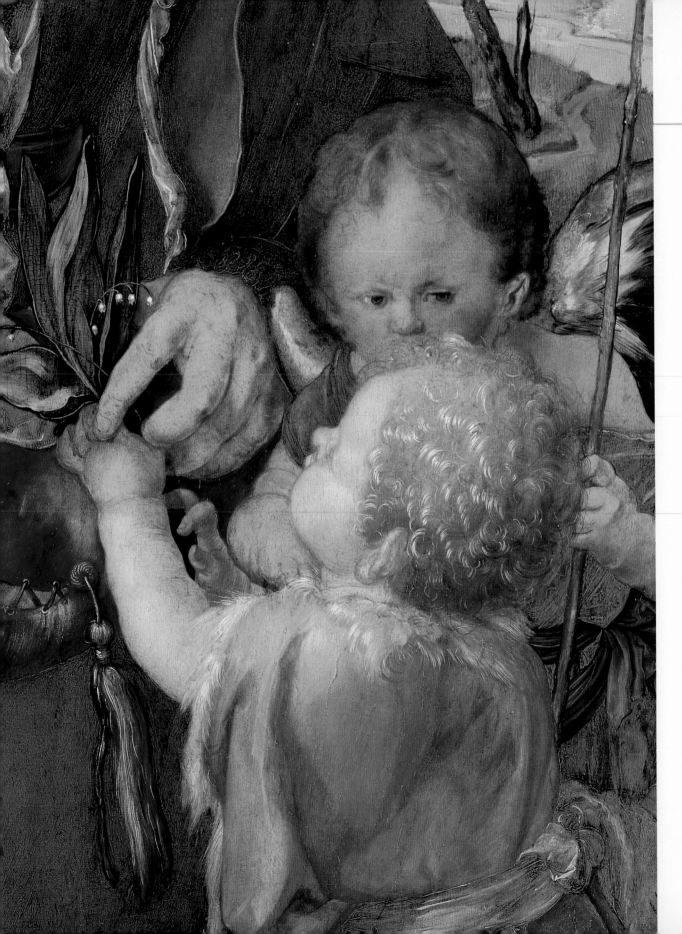

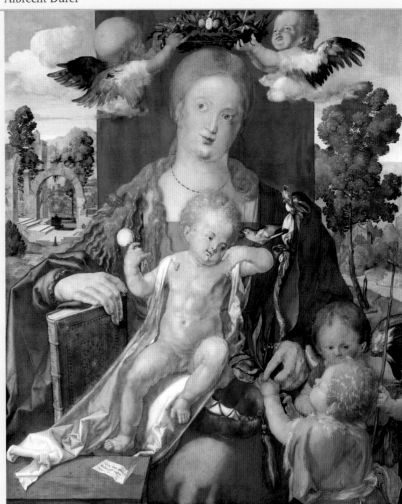

The transition from the Middle Ages to the early modern period in Germany is inextricably linked with the name of Albrecht Dürer. His work reflects the encounter with the fundamental intellectual, political and social problems of an age torn by civil war and peasant revolts. The Gemäldegalerie holds eight paintings by Albrecht Dürer dating from different creative periods in his output. Nuremberg and Augsburg, the most significant artistic centres in southern Germany, maintained close trade relations with Italy, and especially with Venice. Thus, Italy became the preferred destination of young artists on their travels. In 1494–5 and in 1505–6 Dürer travelled to Venice where he came into contact with the works of Italian artists and with Renaissance thought. Dürer painted the *Madonna with the Finch* for an unknown client in 1506, during his second stay in the city. Signing his work 'Albertus durer germanus facebat', the artist – who was greatly impressed by the Italian masters to whom his own painting owes so much – points proudly and self confidently to his own German origin. He wants to document that Germany has also produced great artists who have no reason to be ashamed of their achievements in the field of painting.
R.G.

Albrecht Dürer
(1471–1528)
Madonna with the Finch, 1506
Poplar panel, 91x 76 cm
Acquired 1893
Cat. no. 557F

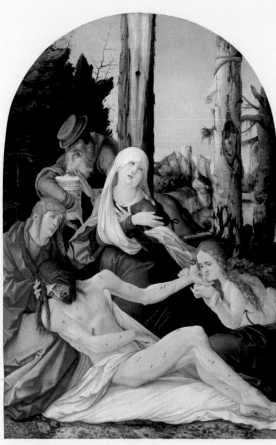

Hans Baldung, known as Grien

Hans Baldung, known as Grien

The composition is dominated by the body of Christ, covered in wounds, who lies on a shroud at the foot of the cross. Behind him sits the grieving Mother of God. John, the favourite disciple, raises the upper body of Christ and supports his head which is falling to one side. Mary Magdalene has, in a gentle gesture, taken hold of the left hand of Christ and brought it to her face. The final figure in the group of mourners is Joseph of Arimathea, a follower and believer in Christ. In his arms he carries a large container of ointment. In the middle ground, to the right, the trunk of the cross to which one of the thieves had been tied can be discerned. All we see of the thief is a bound foot protruding from the trunk. The background shows a peaceful landscape with a castle towering above a steep precipice at the bottom of which is a lake. The artistic execution of the painting is impressive. The athletic body of Christ is shown with all the marks of agony and death and is a testament to the influence of Matthias Grünewald who had presented a brutally realistic depiction of the tormented saviour a few years earlier in his great Isenheim Altar. Baldung's panel may originally have formed the middle part of another altar commissioned by Jakob Heimhofer for his family's chapel in Freiburg Cathedral. R.G.

Hans Baldung, known as
Grien
(1484/5–1545)
The Mourning of Christ,
*c.*1516
Lime panel, 141.3 × 96 cm
Acquired 1907
Cat. no. 603 B

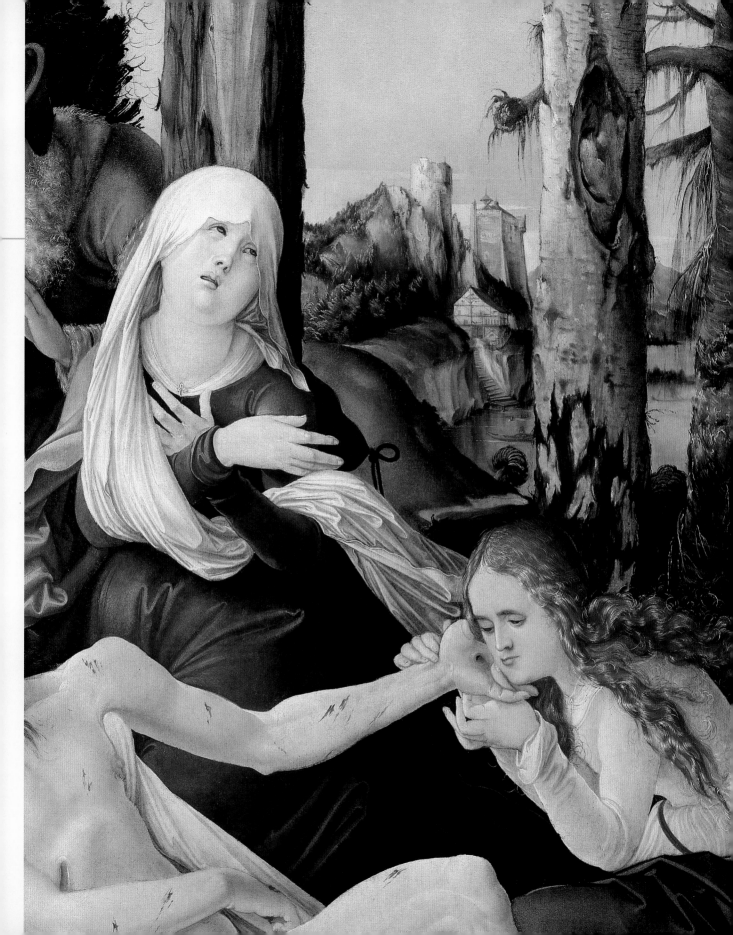

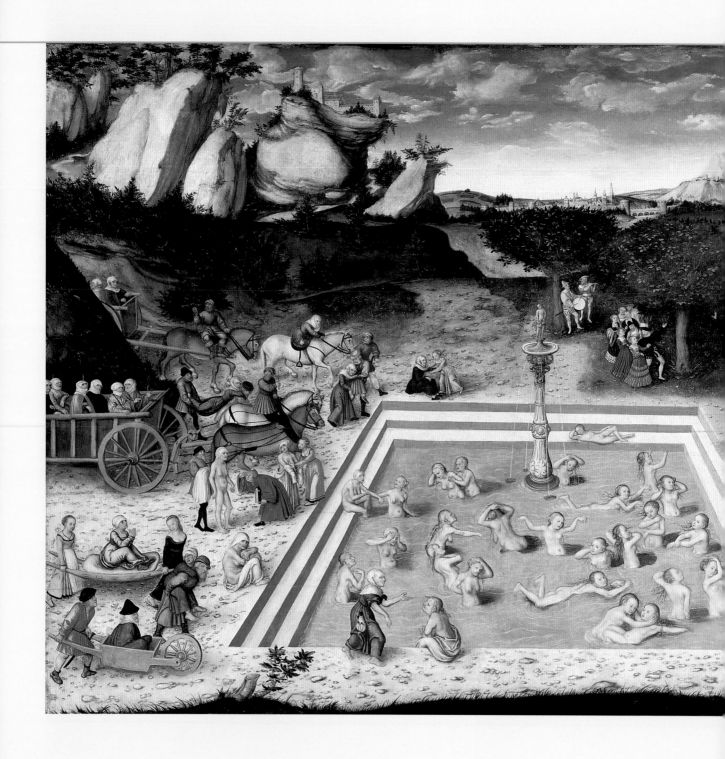

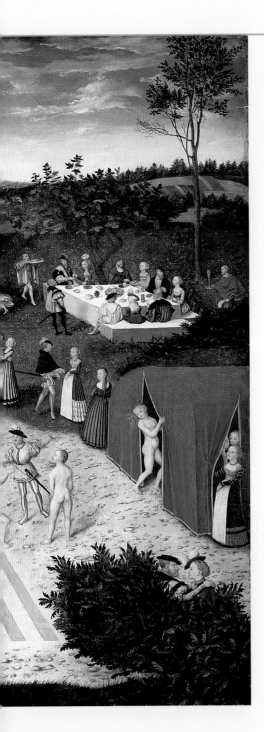

German Painting 13th–16th century

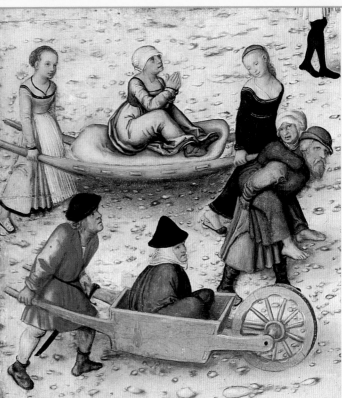

Lucas Cranach the Elder
(1472–1553)
The Fountain of Youth, 1546
Lime panel, 122.5 × 186.5 cm
Acquired from the Royal
Palaces, 1830
Cat. no. 593

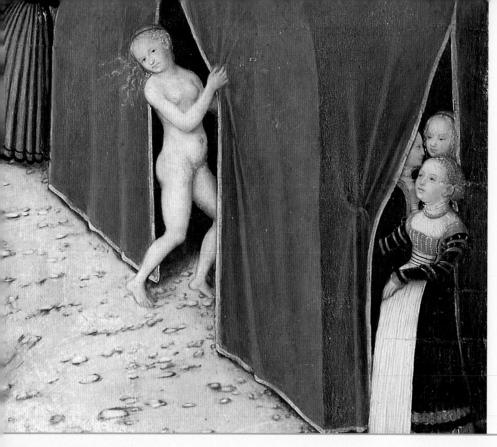

Cranach's painting is about the human yearning for immortality and eternal youth. Human beings dream of being young again, of leaving the worn outer shell and exchanging it for a new one. The notion of the cleansing power of the elements, especially of water, is as old as humankind itself. The centre of the scene is a pool filled with water. Some steps lead down to the pool, which is surrounded by a fantastic landscape far from civilisation. People have undertaken arduous journeys to reach this solitary spot and bathe in the miraculous waters. In the left half of the picture wrinkled and frail old women are brought up on carts and stretchers. They are undressed and examined by a doctor before stepping into the water where the gradual process of rejuvenation takes place. Their wrinkles and old sallow skin disappear, their flesh becomes rosy and smooth, and they turn into young girls. As they emerge from the water they are welcomed by a cavalier who shows them to a tent where they receive new clothes. Old peasant women are transformed into young ladies of the court who indulge in the carefree pleasures of life. The jollifications at the festive table, the dancing, music and lovemaking, all take place in a lush flowering landscape. These are the realms of eternal youth, to which the hardships of old age, set in a barren rocky landscape on the left side of the picture, form a stark contrast. The fountain spouting water from the spring into the pool bears the statues of Venus and Cupid – evidence that this is actually a fountain of love rather than youth, and that the power of love is the true source of immorality.
R.G.

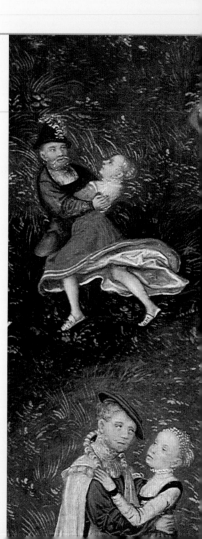

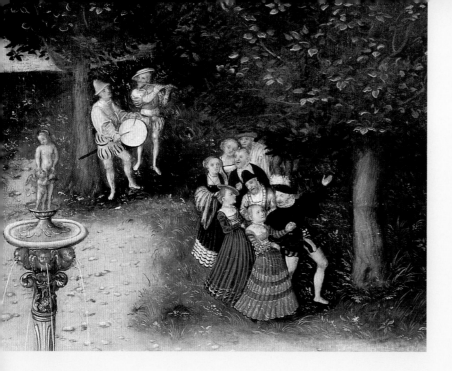

cas Cranach the Elder *The Fountain of Youth* (details)

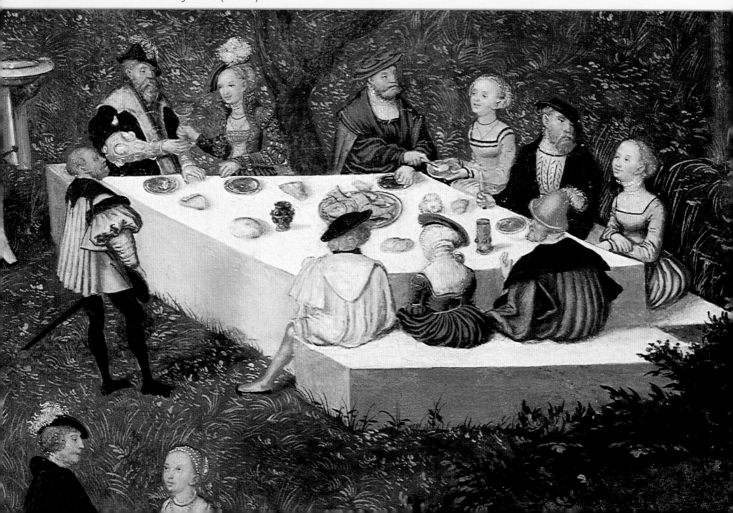

Hans Holbein the Younger

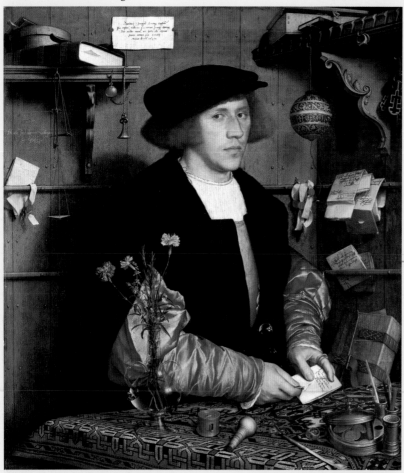

Hans Holbein the Younger
(1497–1543)
The Merchant Georg Gisze, 1532
Oak panel, 96.3 × 85.7 cm
Acquired with the Solly
Collection
Cat. no. 586

The Latin inscription on the painted note above the model's head praises the precision of the portrait. The merchant Georg Gisze of Danzig is shown sitting in his London office. On the table in front of him are a number of objects, including a seal, a pair of scissors, tin writing implements and quills and a clock in a gilded case. Next to the table stands a Venetian glass vase filled with flowers and herbs. Many objects in the painting have symbolic significance. The flowers, which will soon wilt, and the clock serve as a reminder of the passing of time. The fragile glass demonstrates that even the most beautiful things on earth do not last forever. When Georg Gisze was painted by Holbein in 1532, he was one of the leading figures of the London Stalhof, one of the biggest trading bases of the Hanseatic League. The portrait was probably intended as a betrothal picture, to be sent to his bride in Danzig. It is thus linked to Gisze's hope of returning home in the near future, and to his anticipation of domestic happiness after a long period in foreign lands. Gisze did indeed return to Danzig shortly after the portrait was painted, where he was married in 1535 and continued to be held in great esteem.
R.G.

Nulla sine merore voluptas
.G. Gyze:~

JAN VAN EYCK

PETRUS CHRISTUS

ROGIER VAN DER WEYDEN

SIMON MARMION

HUGO VAN DER GOES

HIERONYMUS BOSCH

PIETER BRUEGEL THE ELDER

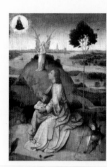
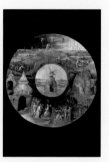

Room 6 Room 6

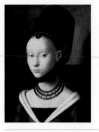

Room 5

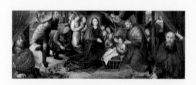

Room v

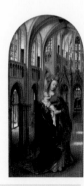

Room 5

Room v

Room iv

Room 7

2

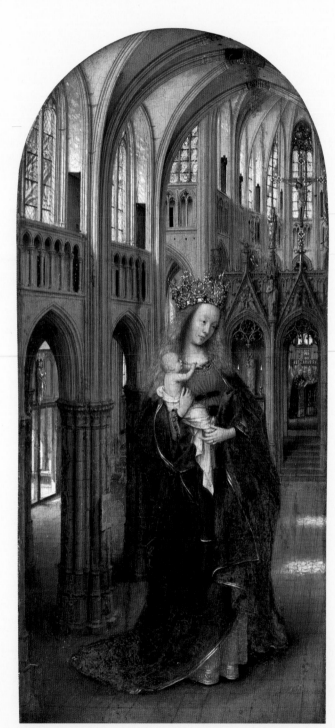

Jan van Eyck

Jan van Eyck's famous depiction of *The Madonna in the Church* is a painting of monumental power, despite its small dimensions. The Mother of God stands in the nave of a Gothic cathedral. Pictured much larger than life – almost bigger than the mind can comprehend – she dominates a space whose architecture is represented in great detail. The light falling through the windows contributes considerably to the natural appearance of the cathedral interior. The patches of light on the floor indicate the sun's position. They warn of the passing of time, but time appears to be standing still within this sacred space. The light that penetrates the windows without shattering them, refers metaphorically to Mary, who gave birth and yet remained a virgin. The light falling in from the north – the choir of a church always points east – is similarly a sign of the supernatural significance of all things. This idea was given tangible expression by the inscription believed to have been present on the (now missing) original frame, in which the mystery of Christ's birth and the virginity of the Mother of God were praised. The jewel-studded crown shows Mary as Queen of Heaven. The burning candles on the altar and the singing angels in the choir refer to the sacerdotal role of Mary and her attribute as House of God and Temple of Christ. R.G.

Jan van Eyck
(*c.*1390–1441)
*The Madonna in the Church, c.*1425
Oak panel, top semi-circular, 31 × 14 cm
Acquired with the Suermondt
Collection, 1874
Cat. no. 525C

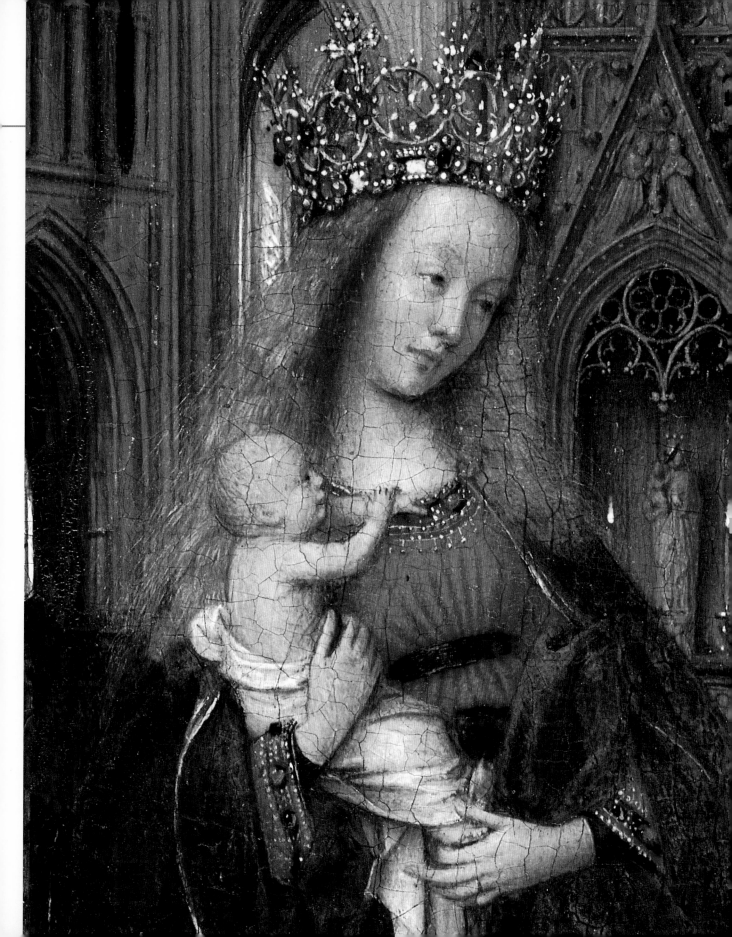

38

Petrus Christus

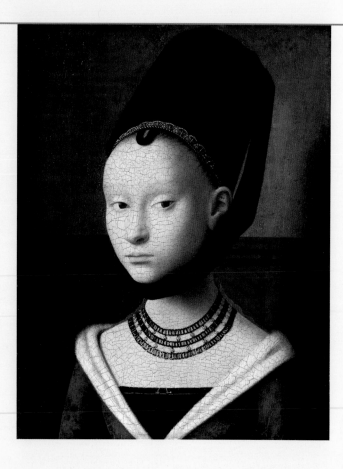

Flemish and French Painting 14th–16th century

Petrus Christus shows his subject in an appropriate interior, something that was never done by Jan van Eyck or Rogier van der Weyden. The transition from neutral background to concrete spatial setting was of great importance in the development of portraiture as it gave the impression that the viewer had gained access to the private sphere of the person portrayed. The young lady studies the viewer with an alert gaze. The pale face with the hair combed back from the forehead, the slanted eyes, the black bonnet, the triple gold chain and the ermine-bordered steel blue dress all contribute to her strange fascination. She undoubtedly belongs to the patrician class, if not the high aristocracy. Many attempts have been made to identify the model. An early reference to Lord Talbot (d.1453) appears to suggest that the sitter was one of his granddaughters, Margaret or Anne, the daughters of the Second Earl of Shrewsbury. The young girls may have accompanied their aunt, the Duchess of Norfolk, to Bruges in 1468 for the wedding of Charles the Bold of Burgundy to Margaret of York. Petrus Christus, who lived in Bruges, could have painted Anne or Margaret on this occasion – in which case the beautiful stranger could be a young Englishwoman.
R.G.

Petrus Christus
(c.1410–72/3)
Portrait of a Young Lady, c.1470
Oak panel, 29 × 22.5 cm
Acquired with the Solly Collection, 1821
Cat. no. 532

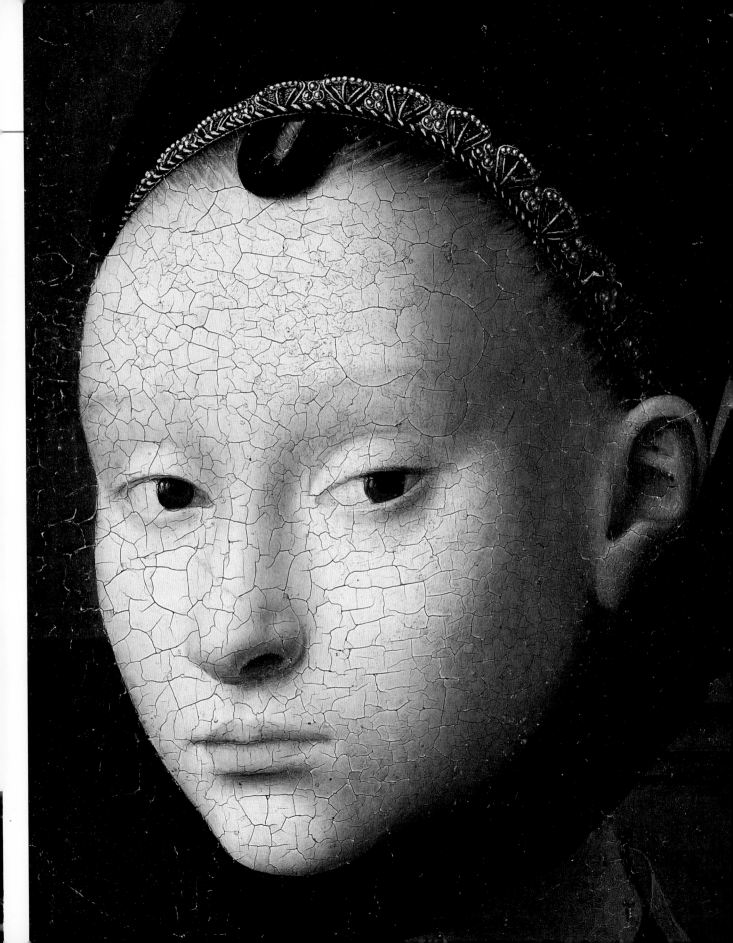

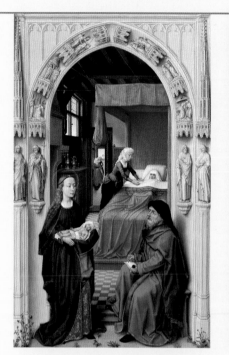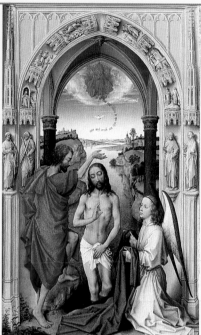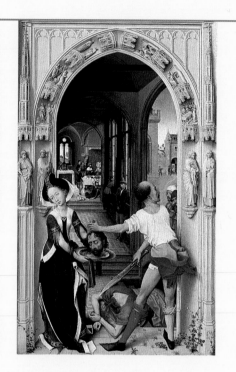

Rogier van der Weyden
(1399/1400–1464)
The St John Altarpiece, c.1455
Oak, each panel 77 × 48 cm
Acquired 1850
Cat. no. 534B

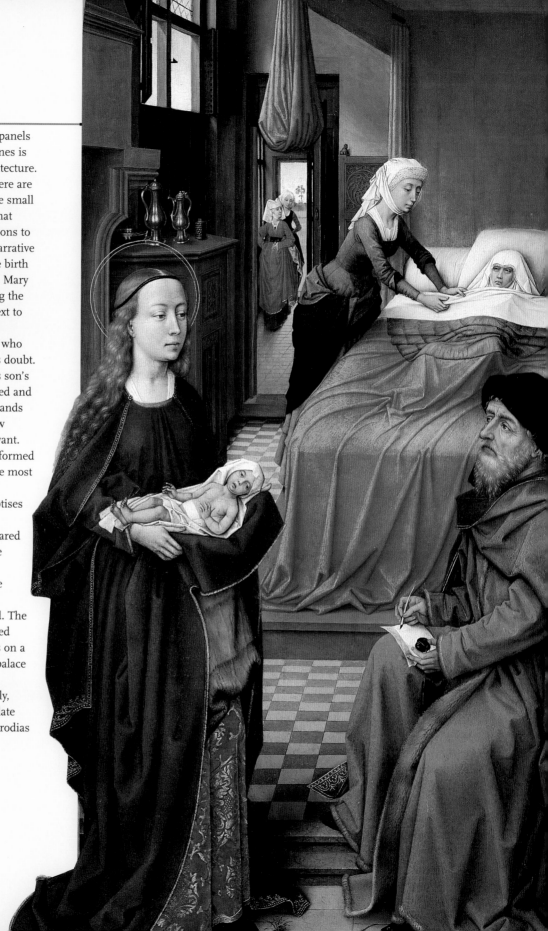

Rogier van der Weyden

The altarpiece consists of three panels
of equal size, each of whose scenes is
framed by a painted portal architecture.
In the cavettos of the arcades there are
numerous painted reliefs, whose small
individual scenes show events that
graphically link the large depictions to
the story of the salvation. The narrative
begins on the left panel with the birth
and naming of John the Baptist. Mary
stands in the foreground holding the
new born infant John. Seated next to
her is Zacharias, who refused to
believe in the birth of a son and who
God struck dumb because of his doubt.
Here, Zacharias writes down his son's
name as the angel had prophesied and
instructed. In the background stands
the bed where Elizabeth, the new
mother, rests, cared for by a servant.
The central scene of the altar is formed
by the baptism of Christ. It is the most
important event in the salvation
narrative. We see John as he baptises
Christ in the waters of the River
Jordan. God the Father has appeared
in the sky above. The dove of the
Holy Spirit is suspended above
Christ. The last panel depicts the
beheading of John the Baptist.
Salome stands in the foreground. The
executioner passes her the severed
head of John, which she receives on a
plate. In the background of the palace
sits Herod with Herodias, the
instigator of the murder. Dutifully,
Salome passes her mother the plate
with the head of John, which Herodias
stabs in her unbounded rage.
R.G.

Simon Marmion

The wings of the altarpiece – painted on both sides – were created for the Benedictine Abbey of Saint-Bertin in Saint-Omer, northern France, by Simon Marmion and are among the supreme achievements of Franco-Flemish arts of the mid-15th century. The altar, consecrated in 1459, was commissioned by Guilaume Fillastre (d.1473), Bishop of Verdun, Toul and Tournai, Abbot of Saint-Bertin and advisor to Duke Philip the Good of Burgundy. The altar shrine, which was destroyed during the French Revolution, was decorated with sculptures, valuable goldwork and semi-precious stones. When opened, the altarpiece must have measured over 6 metres in width. The insides of the wings depict the donor in bishop's vestments followed by scenes from the life and work of St Bertin (d.698). Depicted on the inside of the left-hand wing are the saint's birth, his ordination in the monastery of Luxeuil and the welcome given to him by St Omer in Thérouanne. The closing scene shows the founding and building of the new monastery, whose location was revealed to St Bertin by an angel. The right-hand wing begins with the legend of the miracle of the wine, according to which an empty vat refilled itself. This wine, blessed by the saint, then healed a knight who had been injured falling from his horse. Thereupon, the knight renounced the world and, together with his son, entered the monastery. Later, four Breton nobles were admitted to the order. The picture cycle ends with the temptation of Bertin by a seductress with clawed feet, and the death of the saint among the mourning monks of his monastery.
R.G.

Simon Marmion
(c.1435–89)
The Wings of the Altarpiece of
Saint-Omer: Scenes from the
Life of St Bertin, 1459
Oak, each panel 56 × 147 cm
Cat. nos 1645, 1645A

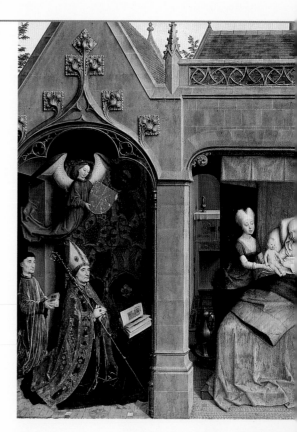

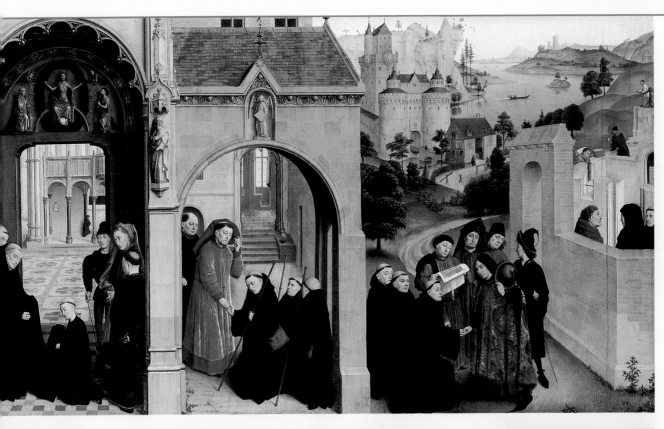

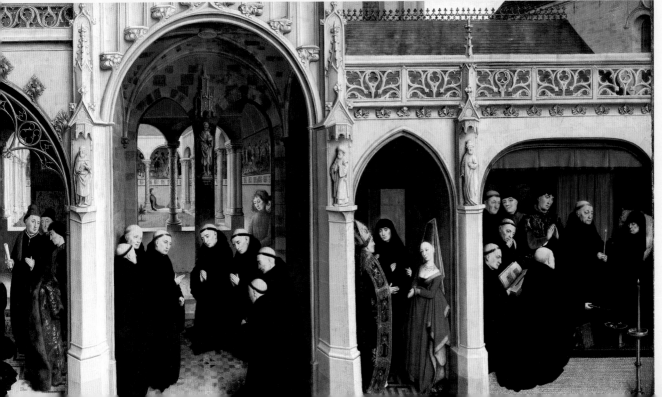

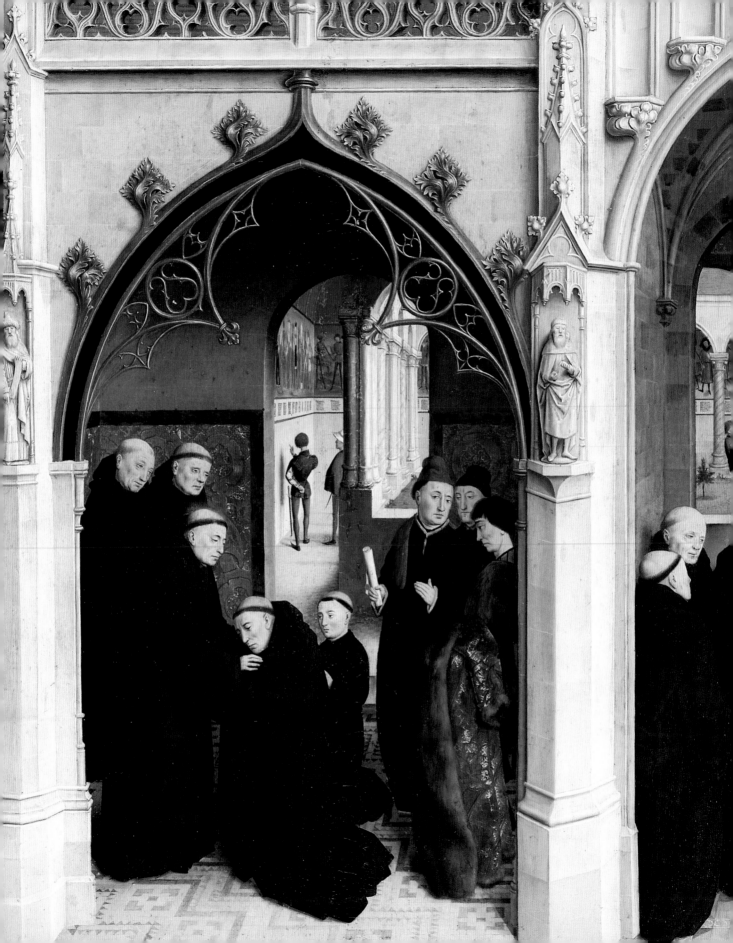

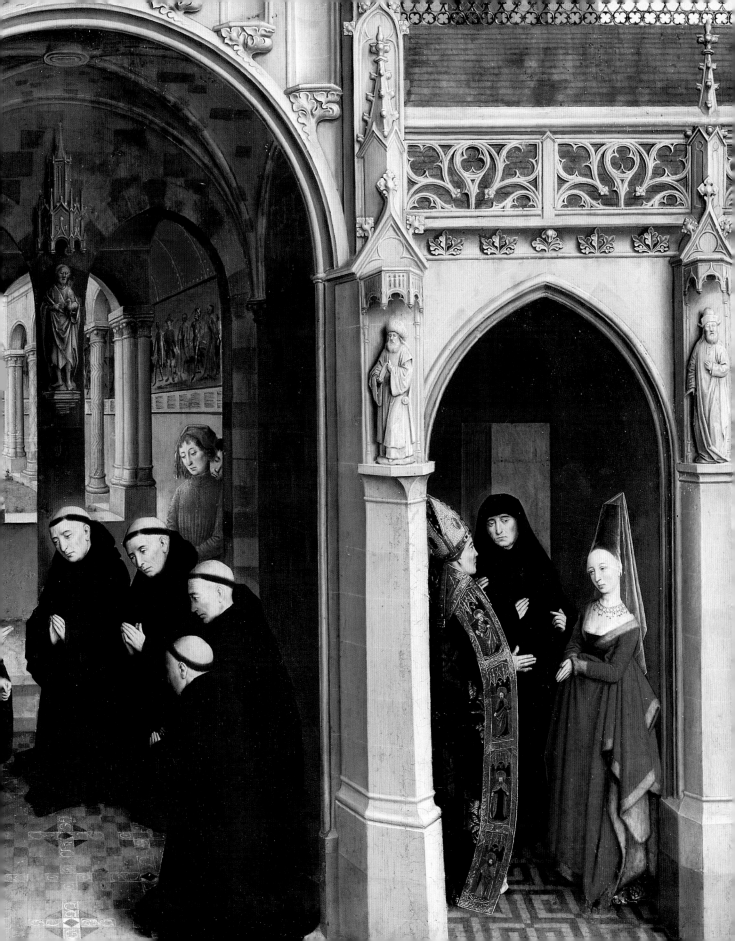

Hugo van der Goes

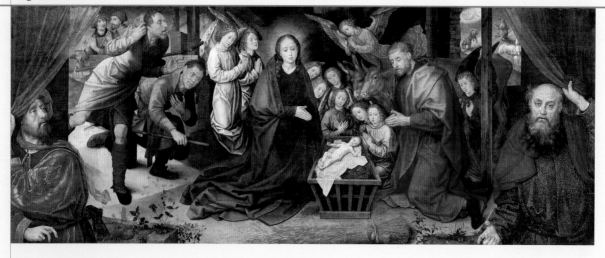

This painting dates from the artist's final creative period. Bouts of depression had led him to turn away from the world and withdraw to a monastery not far from Brussels. *The Adoration of the Shepherds* is in many respects an unusual painting. Especially noteworthy is the extremely wide format of the altar panel and the dynamic arrangement of the composition within the confined space. In the centre of the painting Mary and Joseph kneel next to the crib in which the newborn child lies. Several angels, praying to the child or watching it in silent adoration, crowd between and around these figures. Four shepherds hurry in from the left-hand side, and kneel down at the sight of the miracle of the Nativity, or appear to halt in mid-step with an expression of amazement. The scene is framed on the right and left by the large half-figures of two prophets, who draw back a green curtain in order to reveal and proclaim the wondrous event. As heralds of God's manifestation in human form, they illustrate the deep significance of the event to the viewer. R.G.

Hugo van der Goes
(*c*.1440–82)
*The Adoration of the
Shepherds, c.*1480
Oak panel, 97 × 245 cm
Acquired 1903
Cat. no. 1622A

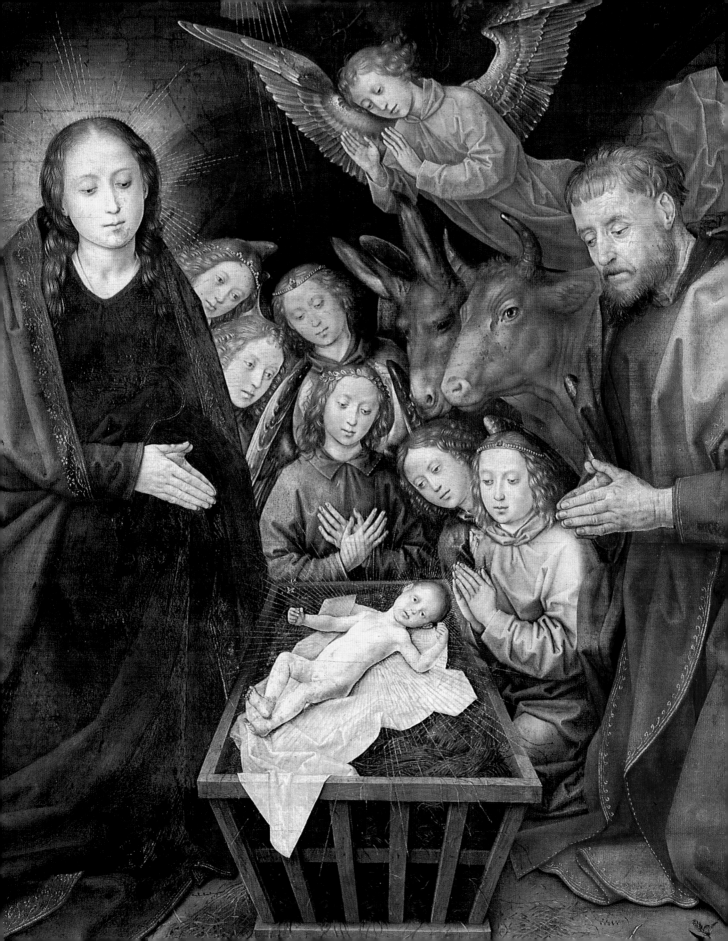

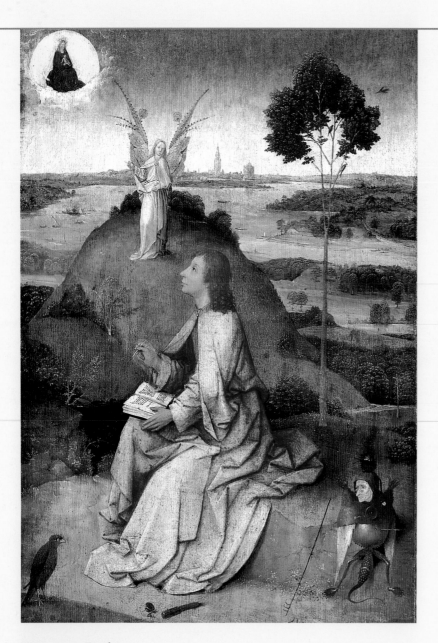

Hieronymus Bosch
(c.1450–1516)
St John on Patmos, c.1505
Oak panel, 63 × 43.3 cm
Acquired 1907
Cat. no. 1647A

Hieronymus Bosch

St John the Evangelist sits on a hill in the foreground of the painting. He holds an open book in his left hand and a writing quill in his right hand. From the hill the view extends across a river landscape reminiscent of the Lower Rhine, but meant to be the island of Patmos, where John received the Revelation of the Apocalypse. An angel points towards the sky, where the Woman of the Apocalypse has appeared. Since the Middle Ages this heavenly vision has been identified with the Madonna. The bird at bottom left is a falcon – a reference to the symbolic animal of the Evangelist, the eagle. The bird guards its master's writing tools, which a demon is trying to steal. Demons also throng the dark reverse of the panel. A circular disc glows brightly in the middle. Depicted in a cyclical arrangement on the disc's outer ring are scenes from Christ's Passion, including the Scene on the Mount of Olives, the Arrest, the Questioning by Pilate, the Scourging, the Crowning with Thorns, the Carrying of the Cross, the Crucifixion and the Entombment. The brightest light, however, is concentrated on the inner circle, which shows a rock rising out of the water. On the peak of the rock is a pelican nest. The bird is shown ripping open its breast with its beak to feed its young with its own blood. Since ancient times the pelican has been considered an allegory of Christ, who saved mankind with his own blood sacrifice.
R.G.

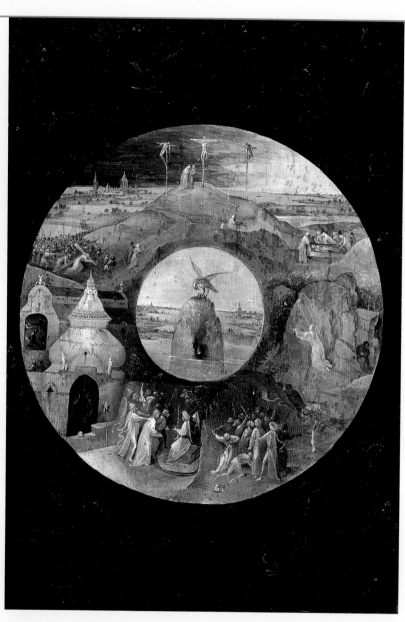

Hieronymus Bosch
(c.1450–1516)
St John on Patmos, c.1505
Reverse: *Grisaille with scenes from
the Passion of Christ*
Oak panel, 63 × 43.3 cm
Acquired 1907
Cat. no. 1647A

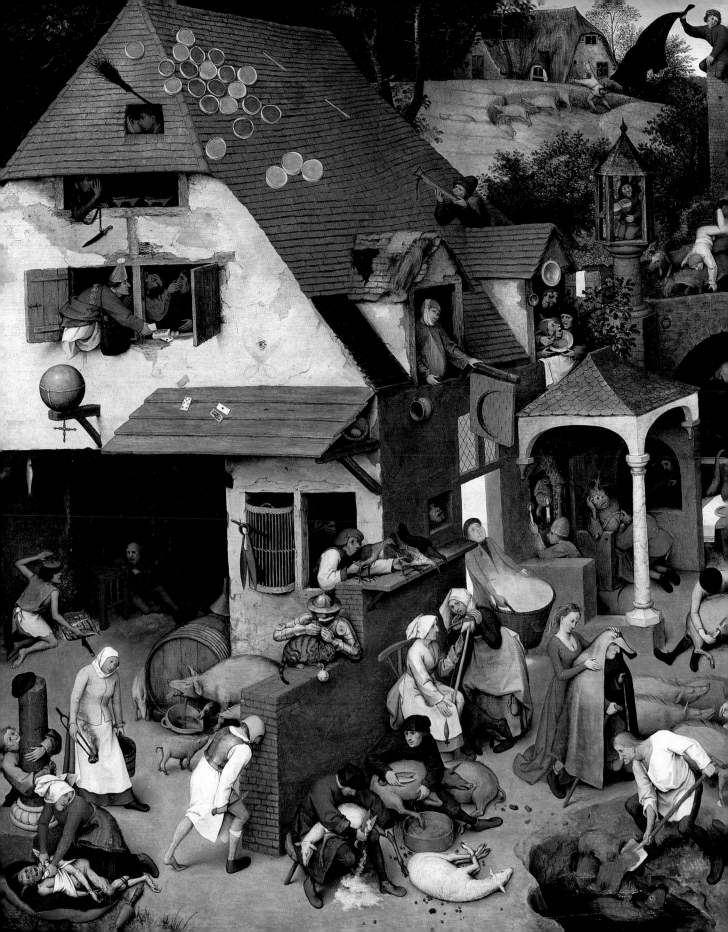

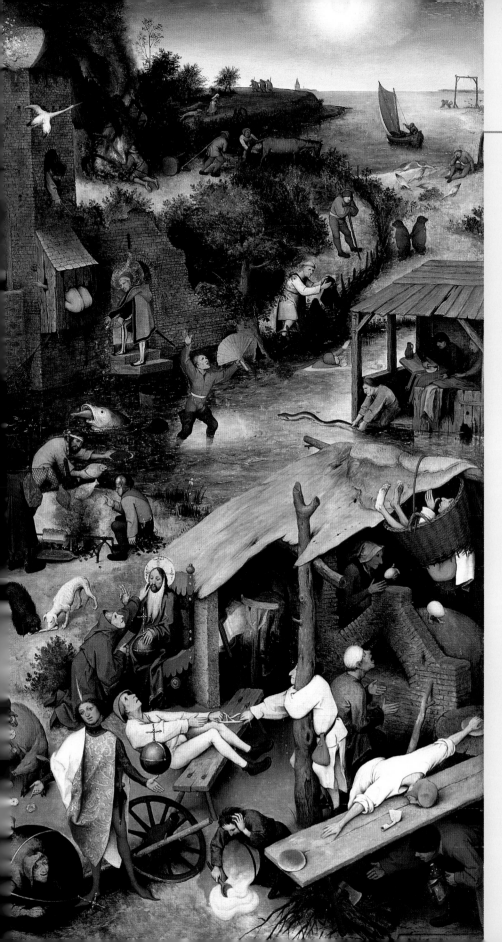

Pieter Bruegel the Elder

This painting, which is set in a village on a river close to the sea, depicts approximately 120 sayings and proverbs. The symbol of the world turned upside down gave the painting its former title, *The Topsy Turvy World*, and refers to a place where humankind is remote from God. The world is ruled not by reason but by folly, as Erasmus of Rotterdam explained so aptly in his *The Praise of Folly* (1511). The portrayal of folly and buffoonery takes up considerable space in Bruegel's painting. The well is filled up only when a calf has drowned, the light is carried to day in baskets, money is thrown into the water, and roses are thrown before swine. Other proverbs allude to the deadly sins. Deceit, lies and hypocrisy are further negative traits exemplified by sayings. It is clear that Bruegel wanted to urge people to grasp the folly of their actions. In this regard, his message is as relevant today as it was in his own time. R.G.

Pieter Bruegel the Elder
(1525/30–1569)
The Dutch Proverbs, 1559
Oak panel, 117 × 163 cm
Acquired 1914
Cat. no. 1720

Pieter Bruegel the Elder

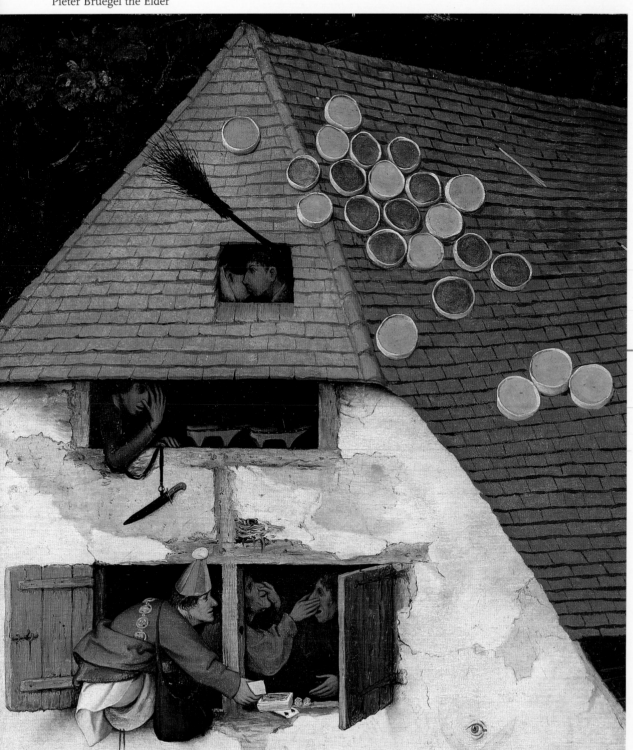

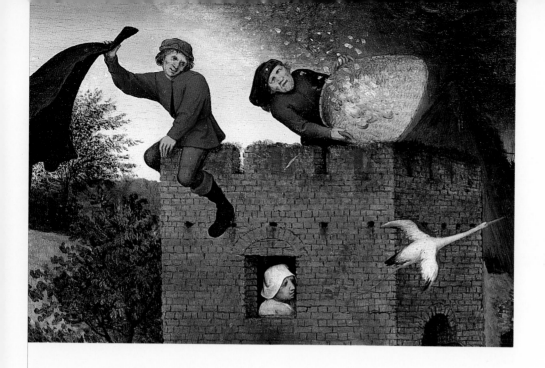

Pieter Bruegel the Elder *The Dutch Proverbs,* (details)

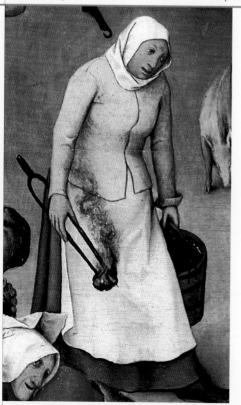

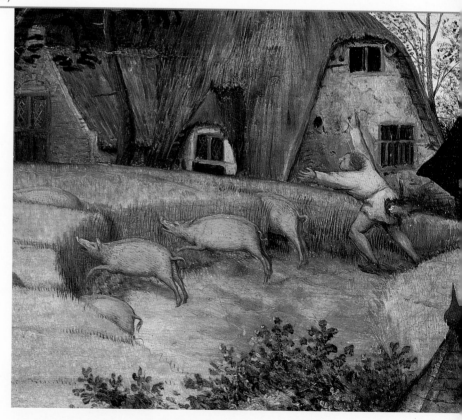

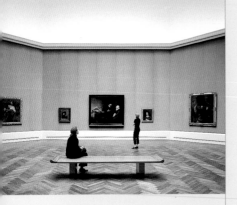

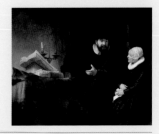

Room X

PETER PAUL RUBENS

JAN BRUEGHEL THE ELDER

SIR ANTHONY VAN DYCK

GERRIT VAN HONTHORST

WILLEM PIETERSZ BUYTEWECH

FRANS HALS

REMBRANDT

JAN VERMEER

JACOB VAN RUISDAEL

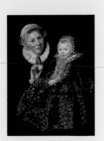

Room VII

Room 13

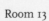

Room VIII

Room 8

Room IX

Room 13

Room 18

Room 15

Peter Paul Rubens

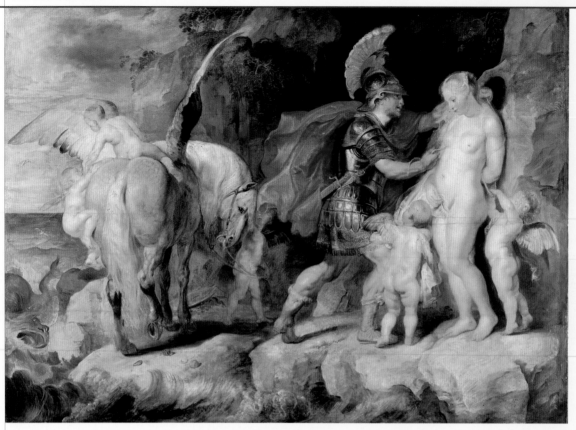

Chained to a rock, Andromeda, daughter of the Ethiopian King
Cepheus, is to be sacrificed to a sea monster in order to atone
for the pride of her mother, who angered Poseidon. As Perseus
is returning home on his winged horse, Pegasus, having defeated
the fearsome gorgon Medusa, he catches sight of the bound
princess. Overcome by her beauty, he approaches her: 'Oh, you
do not deserve chains like these, but only such bonds as unite
ardent lovers'. The scene where the couple meet, which in
Ovid's *Metamorphoses* precedes the battle, is combined in this
painting with the moment of liberation. The monster lies dead
in the water on the left. Perseus loosens Andromeda's chains.
Perseus Freeing Andromeda presents these events convincingly
and with subtle psychological undertones. The powerful
movements of the hero, given lively assistance by putti, and the
serene posture of Andromeda, whose figure is delicately
sculpted in the bright light, communicate the awakening love
fulfilled by the rescue.
J.K.

Peter Paul Rubens
(1577–1640)
Perseus Freeing Andromeda,
*c.*1622
Oak panel, 100 × 138.5 cm
Acquired from the Royal
Palaces, 1830
Cat. no. 785

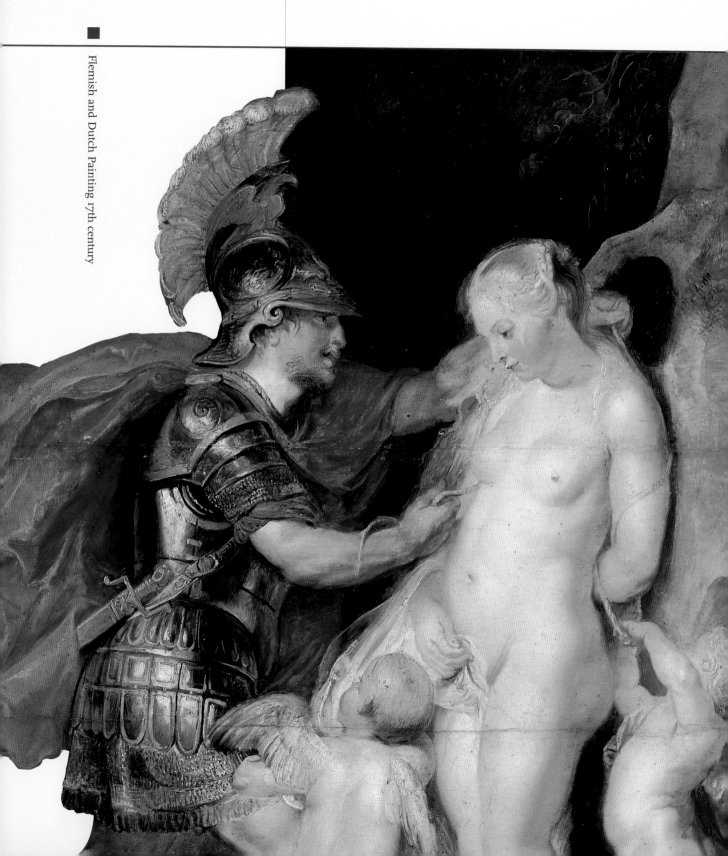

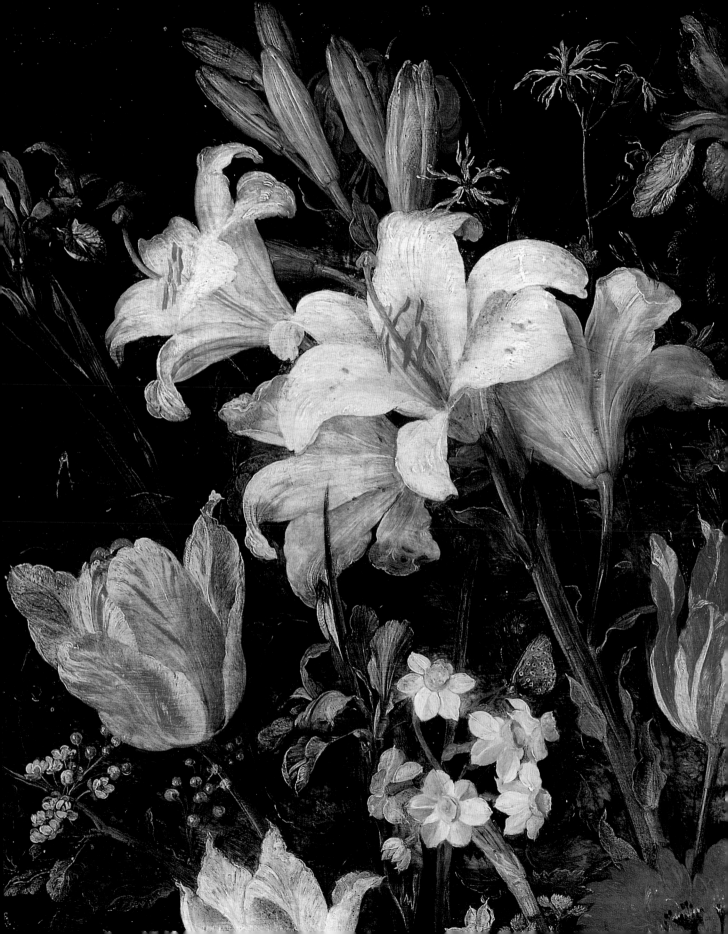

Jan Brueghel the Elder

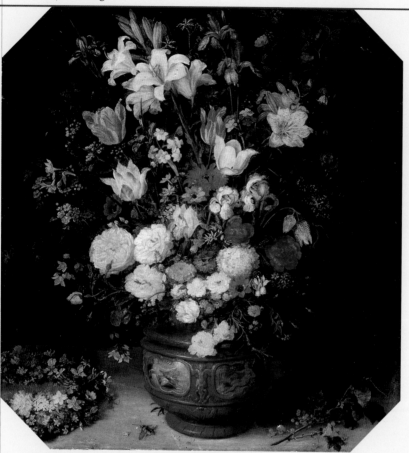

Jan Brueghel the Elder
(1568–1625)
The Bouquet of Flowers,
*c.*1619–20
Oak panel, 64 × 59 cm
Acquired 1862
Cat. no. 688A

The painting depicts flowers of different varieties and flowering times, arranged in a glazed clay vase. The unity of the composition is assured by the somewhat concentric arrangement of the flowers and the balanced distribution of garland and redcurrant sprig on the table, as well as the strict symmetry of the relief decoration on the vase, personifying the elements of water and earth that ensure the flowers' existence and growth. Brueghel's painting can also be understood on another, deeper, level – flowers wilt quickly and so are considered a warning sign that everything earthly is ephemeral.

Jan Brueghel, who painted landscapes and historical works in addition to floral canvases, was the son and pupil of the famous Pieter Bruegel the Elder, whose elemental power of expression he translated into a pictorial language of a more intimate and charming nature.

J.K.

Sir Anthony van Dyck

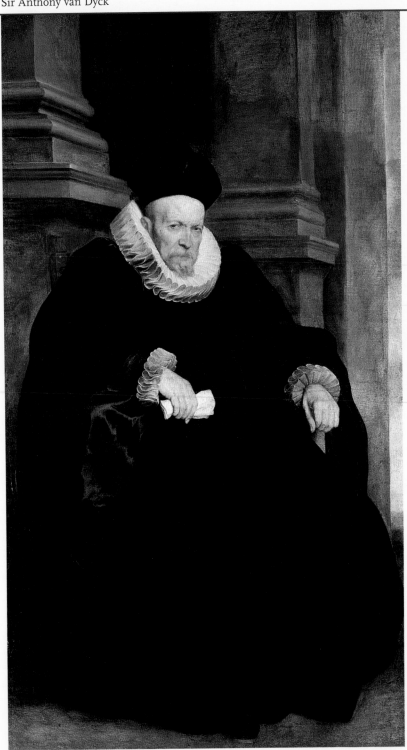

Van Dyck, the most important representative of Flemish baroque painting after Rubens, achieved international recognition for his portraits. The distinguished, unperturbed attitude, cool and distanced, that he lent his models helped to shape the image of the aristocrat that we hold to this day.

The subjects of these two life-size portraits have yet to be identified. They date from van Dyck's stay in Italy (1621–7), most of which he spent in Genoa. The man's features are drawn precisely and are composed from a series of planes. This means his portrait cannot be paired with that of the lady, which is modelled in soft flowing brush strokes of greater plasticity and is much closer to the Flemish style. Her portrait must be somewhat earlier. Differences in setting and perspective further contradict the possibility that the two portraits are counterparts.

What the two models have in common, however, is their high social rank, which they embody – not through the pose of a demand for recognition, but through dignified reserve, borne simply by confidence in their own importance.

J.K.

Sir Anthony van Dyck
(1599–1641)
Portrait of a Genoese Gentleman,
*c.*1621–2
Canvas, 203 × 117.3 cm
Acquired 1901
Cat. no. 782B

Flemish and Dutch Painting 17th century

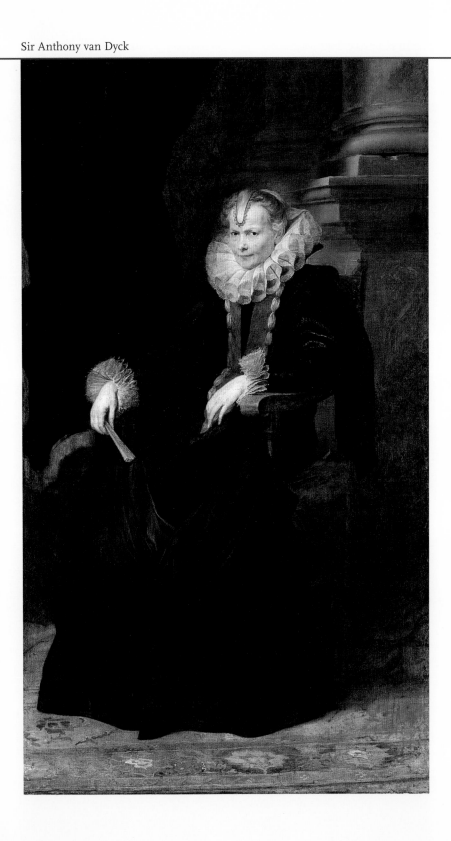

Sir Anthony van Dyck
(1599–1641)
Portrait of a Genoese Lady,
*c.*1621
Canvas, 203 × 118.3 cm
Acquired 1901
Cat. no. 782c

Gerrit van Honthorst

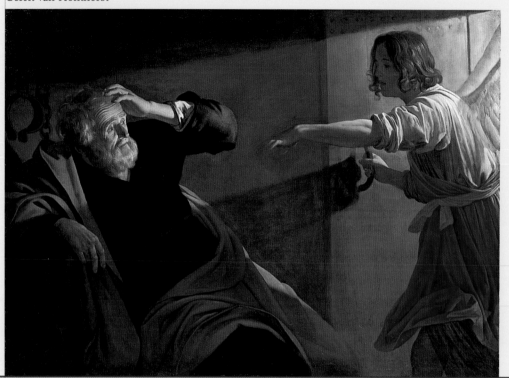

'Arise, quickly!' With this brief cry, the angel exhorts the imprisoned St Peter to leave his opened dungeon (Acts 12: 6–7). The concentration on the essential features of the event – on St Peter and the angel, whose dramatic body language is further emphasised by a richly contrasting interplay of light and shadow – as well as the impressive clarity of the composition of the figures, make the painting clearly Carravagesque in style. In 1615 Honthorst had travelled from Utrecht to Rome, 'when Caravaggio's manner was omnipresent', to grapple there with the art of the great Italian. For all the latter's influence, however, Honthorst maintains his own view of things, which earned him respect. This picture was commissioned by the Marquis Vincenzo Giustiniani, who was a patron of Caravaggio and the Caravaggists.
J.K.

Gerrit van Honthorst
(1590–1656)
The Deliverance of St Peter,
c.1616–18
Canvas, 131 × 181 cm
Acquired 1815
Cat. no. 431

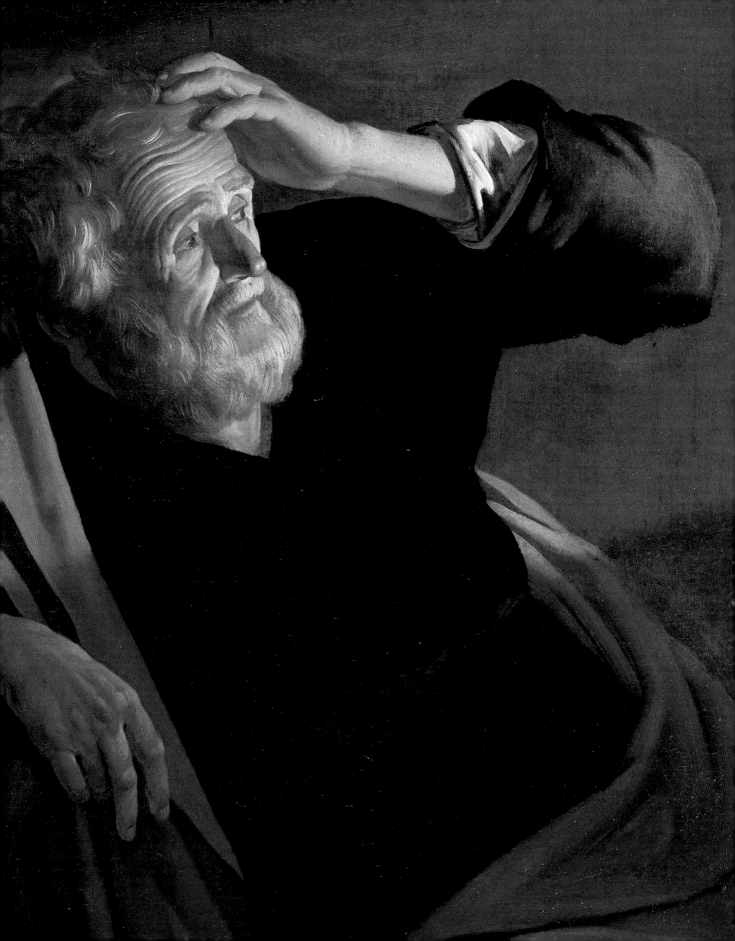

Willem Pietersz Buytewech

Frans Hals

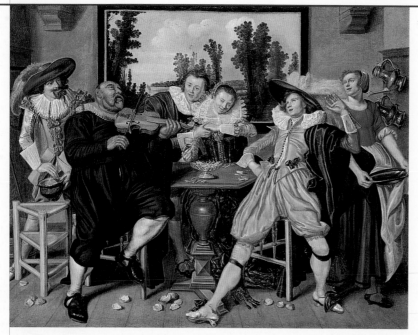

Actions, glances and the absence of a foreground draw the viewer into the
activities of this apparently merry public house. The onlooker participates in, or
is supposed to confront at close quarters, a party of young ladies and gentlemen
whose foppish elegance and sensuality leave no doubt that Holland's *jeunesse
dorée* has been represented in the midst of questionable pursuits. The painting
depicts a negative example, which admonishes the viewer not to follow the
example of the prodigal son, who squandered his inheritance in loose society.
The figures are arranged in strict symmetry, but the painting in fresh colours
dominated by blues, reds and yellows, nevertheless gives the impression of life
grasped in its immediacy.
J.K.

Willem Pietersz Buytewech
(1591/2–1624)
*Interior with Merry
Gathering, c.*1620–22
Canvas, 65 × 81.5 cm
Acquired 1926
Property of the Kaiser
Friedrich Museum Society
Cat. no. 1983

Both the young model's self-assured
demand for admiration and the nurse
in attendance indicate a protected
childhood in the upper reaches of
society. Pictured is Catharina Hooft,
born 1618, who was to become one
of the country's leading ladies when
she married the Mayor of Amsterdam,
Cornelis de Graeff, in 1635. While
posture and dress reveal social rank,
the real statement is made by the
model herself, whose gaze emanates
an absence of prejudice. To under-
stand and reproduce a human being
positively in his or her own reality –
that is the crux of the novelty of Dutch
portraiture, which, before Rembrandt,
was fundamentally shaped by Frans
Hals.
J.K.

Frans Hals
(1581/6–1666)
*Catharina Hooft with her
Nurse, c.*1619–20
Canvas, 86 × 65 cm
Acquired 1874
Cat. no. 801G

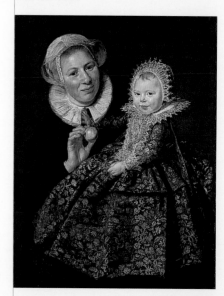

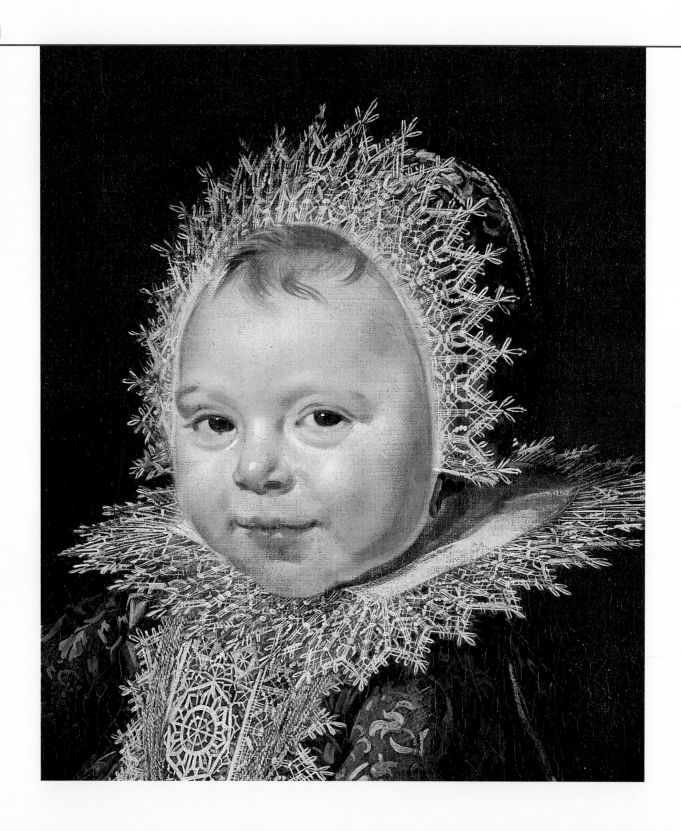

Rembrandt

Cornelis Claesz Anslo (1592–1646) was a successful entrepreneur as well as one of the leading clergymen of Holland's Mennonites. A preacher famous for his oratorical skills, he presided over the Waterland community in Amsterdam. The choice of a large format for the painting suggests that it was commissioned by the wealthy businessman himself. However, it is not this profession, but that of the preacher, which is represented here. 'Now then, Rembrandt, paint Cornelis's voice, / the visible is his least important part: / the invisible one can only learn by ear. / He who wants to see Anslo must hear him.' This challenge was made by Joost van den Vondel, the most famous Dutch poet of the period. In the portrait Anslo is shown interpreting the Bible – which is resting opened on the desk – for his wife, Aeltje Gerritsdr. Schouten (1589–1657). The impressively eloquent gesture of his left hand, which marks the centre of the entire composition, seems to break through the painting's surface and underlines his words. The 'spoken word' has become the painting's paramount object. It justifies the juxtaposition of the figures and presents it, much like a history painting, to the onlooker as a completed sequence of actions.
J.K.

Rembrandt
(1606–69)
*The Mennonite Preacher
Anslo and his Wife*, 1641
Canvas, 176 × 210 cm
Acquired 1894
Cat. no. 828L

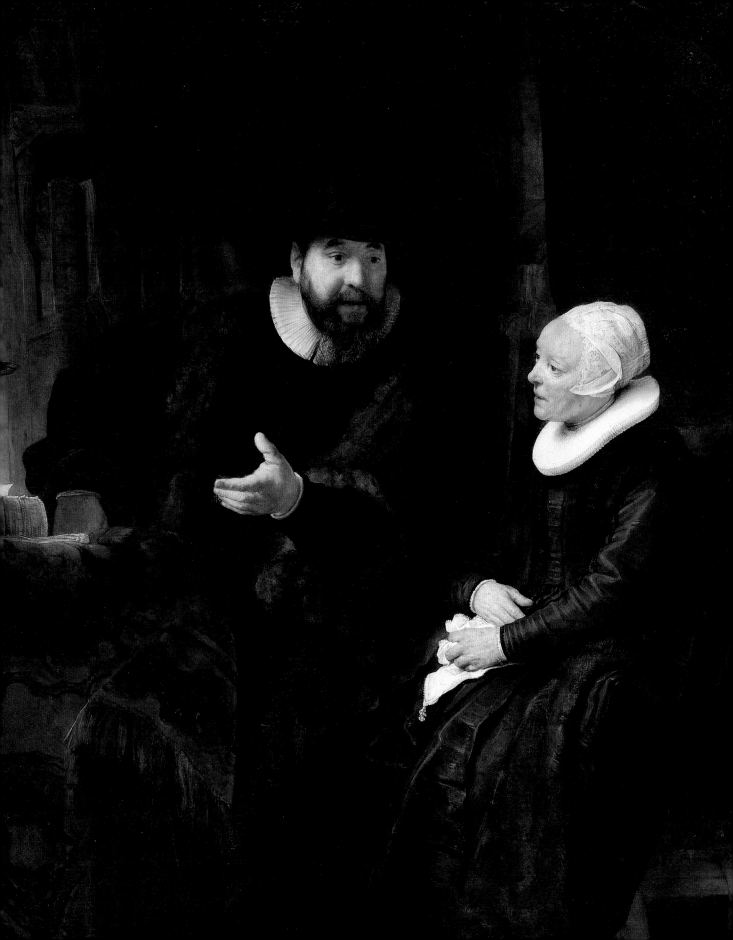

Jan Vermeer

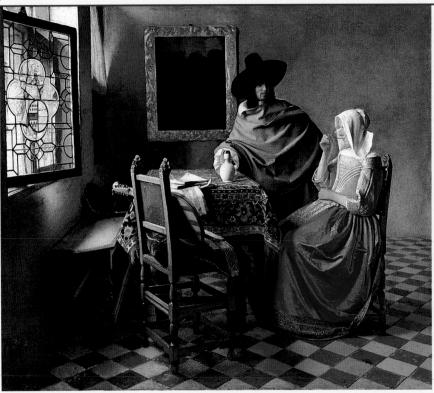

Jan Vermeer
(1632-1675)
The Glass of Wine, c.1658–61
Canvas, 66.3 × 76.5 cm
Acquired 1901
Cat. no. 912C

In the cool daylight falling through the window from the left, a young woman sits at a table drinking wine. She holds the empty glass tipped towards her face, as if she wants to evade the eyes of the waiting cavalier who is ready to refill her glass (he holds the wine pitcher in his hand, but has no glass of his own). An amorous relation of questionable character is in the offing, yet there is nothing coarse or obviously erotic about the proceedings. *Serva modum* (observe moderation)! This admonition to lead a virtuous life is represented by the figure of Temperantia (Self-restraint) who appears in the heraldic pane of the window with her attribute the harness.

The picture's clean composition, which contains nothing chance or incidental, corresponds to the expression of calm appropriateness emanating from the two figures. In the omnipresent beauty of the light, the world of the painting as a whole appears to be raised to a higher plane. Thus it is difficult to see any threat to propriety, through excessive enjoyment of the wine, embodied in the woman whose silk dress, like fresh roses, lights up with cool nobility.
J.K.

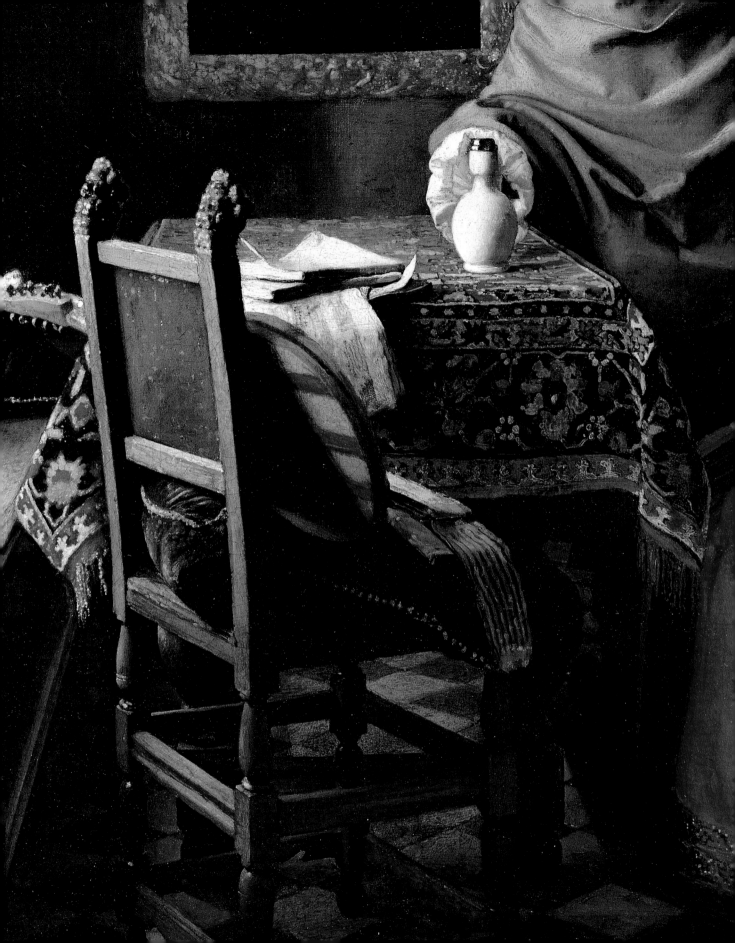

Jacob van Ruisdael

From the elevated position of the dunes to the northwest of Haarlem, the eye catches sight of the red-tinged roofs of the town, the mighty structure of Saint Bavo and the other churches, the town hall and, at the edge of the town, the many windmills on the ramparts. The cloudy sky, reaching up from a low horizon, is reflected in the flat countryside in the interplay of strips of light and shadow. Long linen cloths are spread out to bleach on the meadows in the foreground – at the time of the painting linen manufacture was an important industry of the town. Ruisdael accorded the bleaching of linen an important place in nearly all his *Haarlempjes*, about 20 of which have survived.

Allegorical interpretations of *Landscape with a View of Haarlem*, which go beyond the topographical and refer to the virtue of the purity of the soul, cannot be excluded. Goethe had already characterised Ruisdael as a 'poet' and admired the 'perfect symbolism' in his works. The combination of a composition drawing on nature and an ambitious statement in terms of content is indeed one of the most important stylistic features of Ruisdael, in whose art Dutch landscape painting of the 17th century reached its impressive peak.

J.K.

Jacob van Ruisdael
(*c*.1628–82)
*Landscape with a View of Haarlem, c.*1670–75
Canvas, 52 × 65 cm
Acquired 1874
Cat. no. 885c

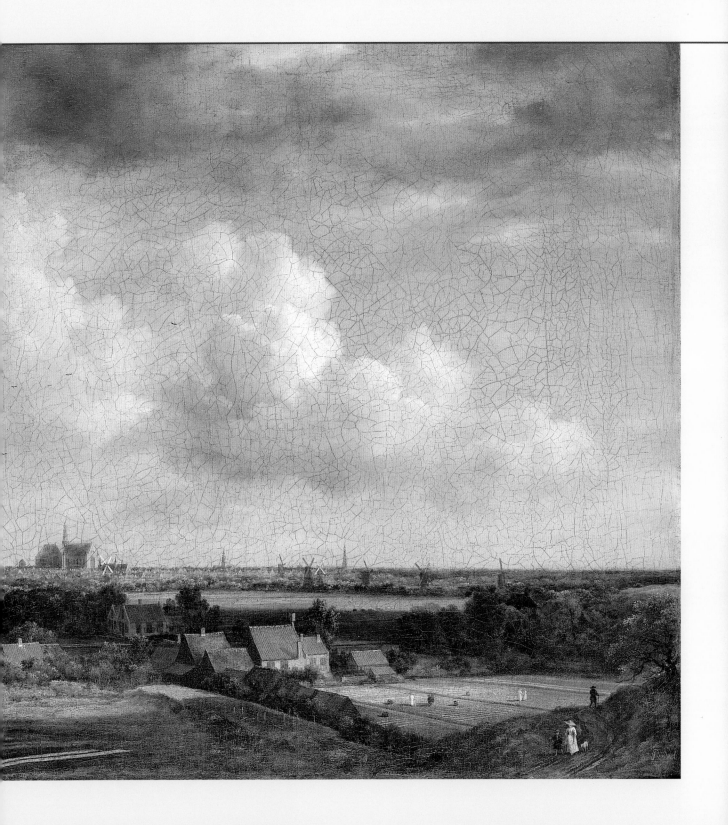

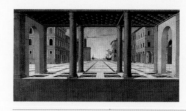

Room XVIII

GIOTTO DI BONDONE

GENTILE DA FABRIANO

ANTONIO DEL POLLAIUOLO

FRA FILIPPO LIPPI

SANDRO BOTTICELLI

FRANSCESCO DI GIORGIO
MARTINI

ANDREA MANTEGNA

GIOVANNI BELLINI

TITIAN

RAPHAEL

FRANCESCO MELZI

LORENZO LOTTO

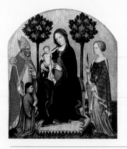

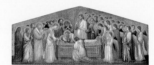

Room 41

Room 40

Room 32

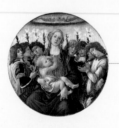

Room XVIII

Room XVII

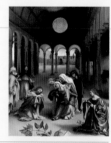

Room XVIII

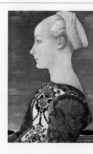

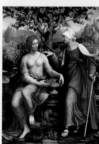

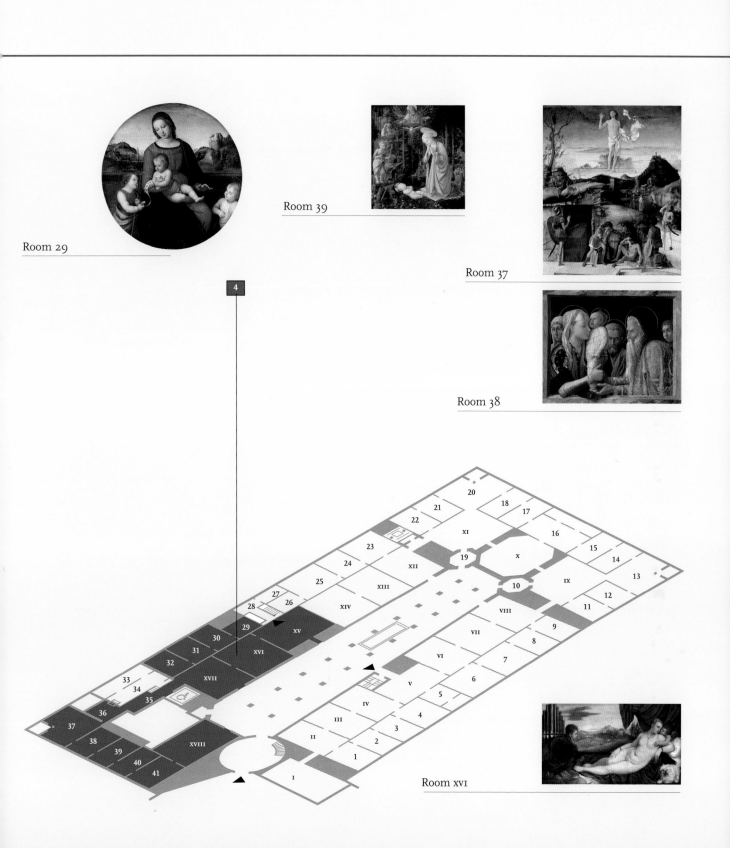

Room 29

Room 39

Room 37

Room 38

Room XVI

Giotto di Bondone

Wilhelm von Bode's final acquisition for the collection of trecento panels was seen in the 15th century by the sculptor Lorenzo Ghiberti in the convent of Ognissanti in Florence. The shape of the altarpiece corresponds to the hieratic positioning of the central group: Christ towers in the middle, holding the soul of Mary in the shape of a small innocent child; below them, Mary's corpse lies stretched out horizontally. The severity is supplemented by a new tendency towards movement – we are witnesses to a scene that encompasses both funeral mass and burial. Figures with their backs turned guide the viewer's gaze into the pictorial space; the carefully varied positions of the numerous mourners draw attention to the dramatic climax; precisely observed details in the demeanour of those present stand for the concrete situation. The space is represented only by the compact, rounded bodies in a clearly graduated perspective. Apart from the sarcophagus, all firm definition of locality is omitted in favour of intense concentration on the action.

H.N.

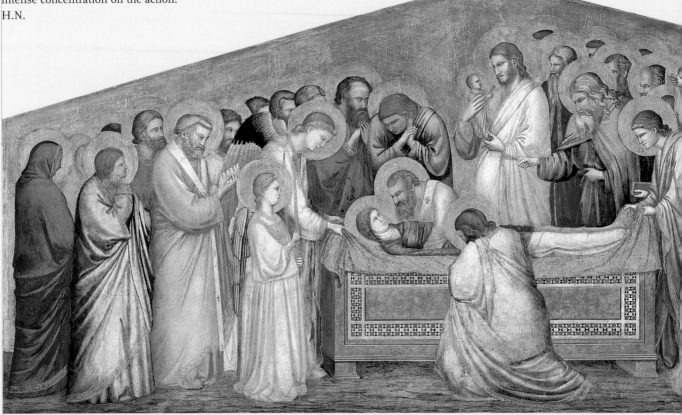

Giotto di Bondone
(c.1267–1337)
The Burial of the Virgin, c.1310
Poplar panel, 75 × 179 cm
Acquired 1914
Property of the Kaiser Friedrich
Museum Society
Cat. no. 1884

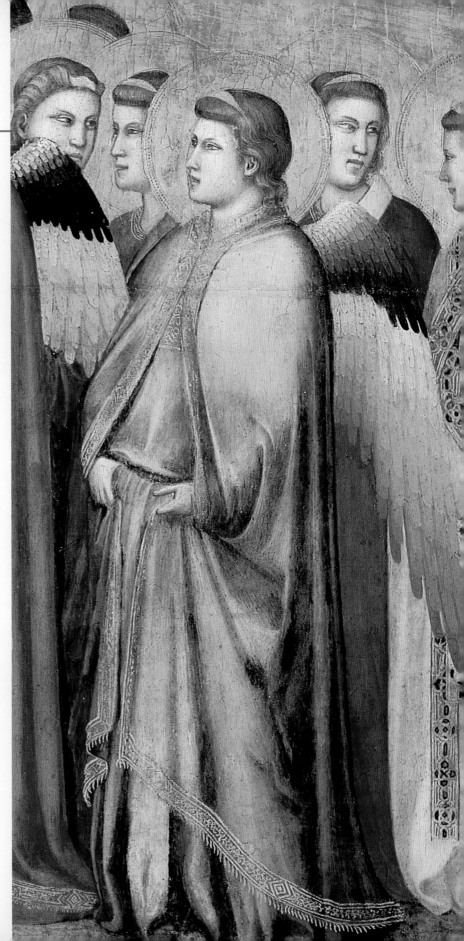

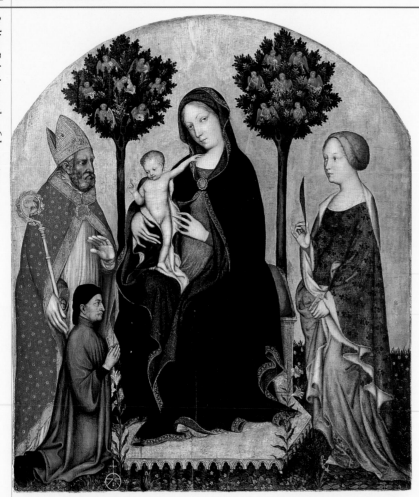

Gentile da Fabriano
(*c.*1370–1427)
Virgin Enthroned with the Infant Jesus, Saints and a Patron
Poplar panel, 131 × 113 cm
Acquired 1840
Cat. no. 1130

This panel, presumably from San Niccolò in Fabriano, may well be the master's earliest work. It is guided by the aesthetic ideals of high international Gothic – linear elegance, harmonic composition of planes, lavish colours and a rich use of gold. Gold also symbolises the heavenly light that surrounds Mary and the beneficial Child. She is enthroned in Paradise, traditionally indicated by trees and the meadow of flowers. Angels, as 'heavenly birds', play golden instruments. Their red hue marks them as pure, spiritual beings of the Kingdom of God. The Madonna is the intermediary between God and humanity. Hence the patron saint of the church, St Nicholas (i.e. San Niccolò), recommends to her the unknown donor of the panel, who kneels in prayer at her feet on the lower left of the painting. The monogram on his ring and in foreground of the painting has yet to be identified. In his humility, he had himself depicted on a much smaller scale than the Virgin. The figures of saints Nicholas and Catherine were also represented on a smaller scale, in accordance with the rules of 'perspectives of importance'.
H.N.

Antonio del Pollaiuolo

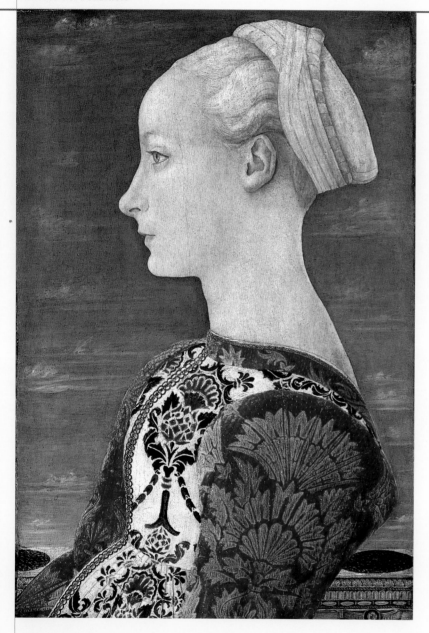

This portrait was acquired for Berlin in 1894 as an outstanding masterpiece of the early Renaissance. After detailed stylistic examination, earlier attributions were rejected in favour of the Florentine Antonio del Pollaiuolo. The painter chose an elongated format for his depiction of the very young lady, one which is particularly appropriate for the lively contour of the graceful figure and the fine lines of her delicate face. The model poses against a blue sky, probably under a pergola. This friendly, neutral background is necessary to set off the fair hair and the almost undifferentiated, very delicate complexion in the gentle, evenly distributed light. The complexion appears even more transparent in contrast to the large patterned, strongly coloured brocade cloth. The strict horizontal of the marble balustrade balances the unstable suppleness of the figure. Youth and graceful pose are brought into harmony. The young woman evidently belonged to the upper ranks of Florentine society, though we do not know who she was nor who originally commissioned the painting. The occasion may have been an engagement or a wedding. H.N.

Antonio del Pollaiuolo
(c.1431–98)
Profile Portrait of a Young Woman,
*c.*1465
Poplar panel, 52.5 × 36.25 cm
Acquired 1894
Cat. no. 1614

Fra Filippo Lippi

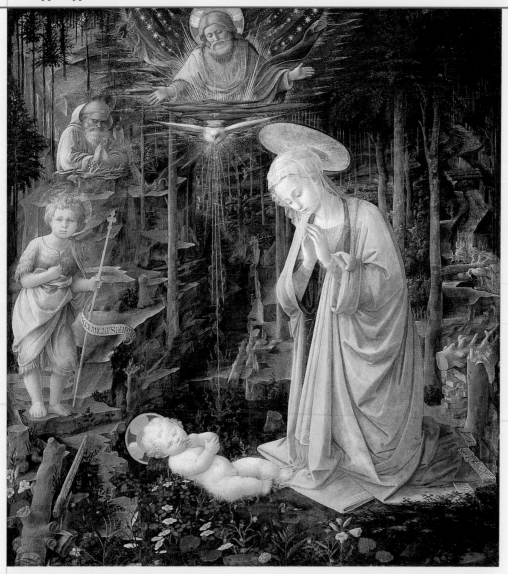

The altar painting from the chapel of the Palazzo Medici in Florence depicts, first of all, an idyllic woodland as the dwelling place of hermits. On the left of the picture we see St Bernard, one of the principal representatives of medieval mysticism, and John the Baptist, who is said to have gone into the wilderness as a child. Like Mary, they are adoring the Infant Jesus as the Son of God, whose extreme sacrifice is the precondition, in Christianity, for the salvation of mankind. Suspended above him are God the Father and the dove of the Holy Spirit. Humankind, too, can follow the example of the saints and contribute to their own redemption by a readiness to repent. Numerous symbols in this theologically demanding picture refer to the Passion, Christ's love, the victory over evil, repentance and the passing of all earthly things.
H.N.

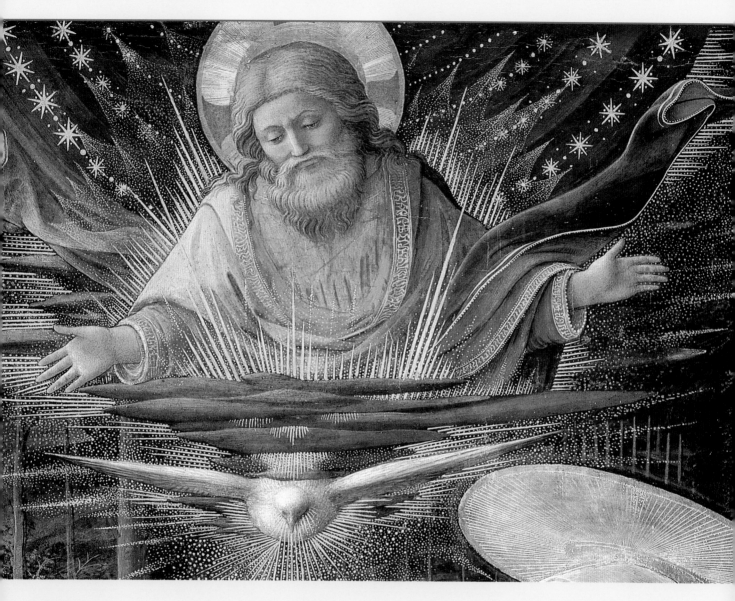

Fra Filippo Lippi
(*c.*1406–69)
The Adoration in the Forest,
*c.*1459
Poplar panel, 129.4 ×
118.6 cm
Acquired with the Solly
Collection, 1821
Cat. no. 69

Sandro Botticelli

This unusually large tondo is probably from the Florentine Church of San Francesco (today San Salvatore al Monte). The format was inspired by relief art and flourished only briefly. Botticelli's masterpiece is considered one of the highpoints of the form's development: He did not simply transpose the ordering principles of more usual picture formats on to the round, but subtly adjusted the contours, the plasticity, the positioning and postures of his figures to the demands of the geometrical shape. Perspectively circling movements and spatially rounded groupings find their central point in the figure of the Virgin. Angels bearing lilies, the symbol of virginal purity, praise her. As Queen of Heaven, she receives the crown from the Hand of God. The Christ child is held to her breast in an allegorical explicable, ceremonial gesture: Mary feeds him wisdom and is simultaneously presented as the Mother of all humankind, the mediator between mortals and God the Father. From a theological viewpoint, she is as much a part of the work of salvation as the Son of God in the future Passion. The gaze of both the Christ child and of the angels on the picture's left call upon devout beholders of the scene to immerse themselves in the Mystery and share in the melancholy pre-monition of the way of the cross. In the past, believers would immediately have grasped this aspect of the painting. In its masterly form and festive colours it does justice to the great demands of the adoration of the Virgin Mary.
H.N.

Sandro Botticelli
(1445–1510)
Virgin and Child with Singing Angels, c.1477
Poplar panel,
diameter 135 cm
Acquired 1954
Cat. no. 102A

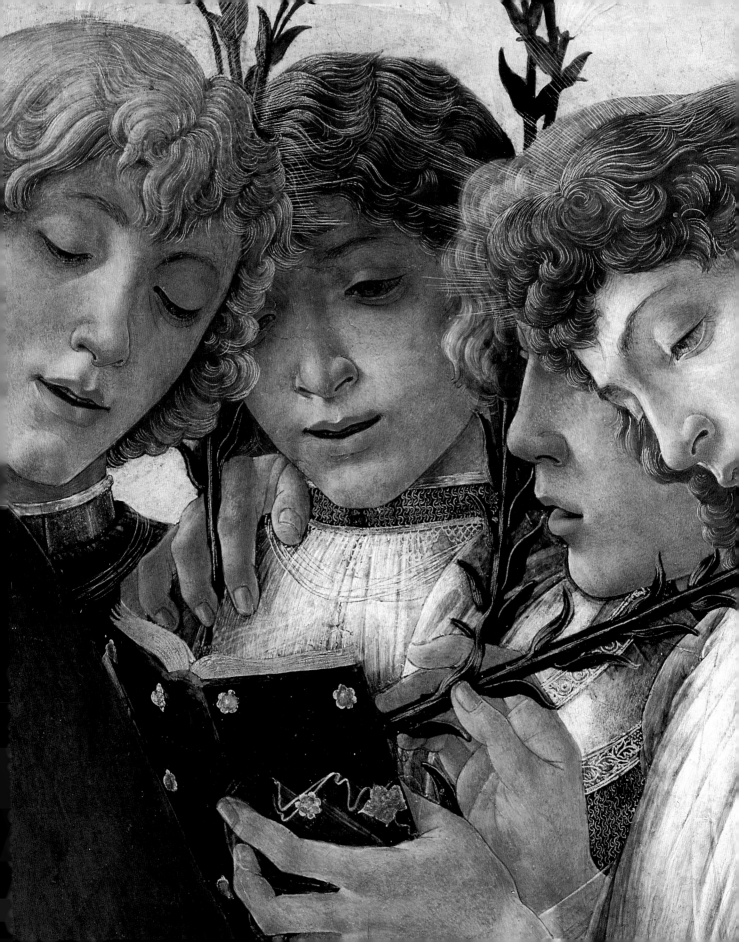

Attributed to Francesco di Giorgio Martini

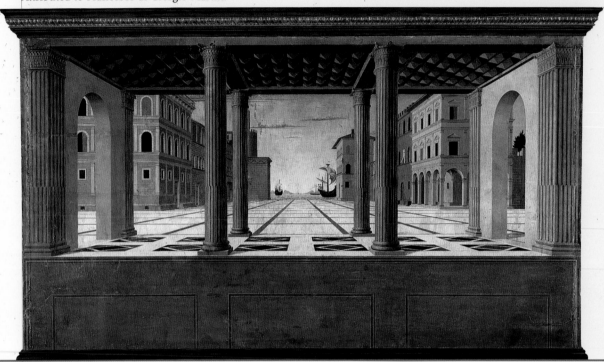

This architectural depiction, unusual for its time, is ascribed to the painter, sculptor and architect Francesco di Giorgio. The fact that it contains piers and harbours that match the description of such structures in his treatise on architecture helps to firm the painting's provenance. It remains unclear whether it was executed by the artist himself or based on a draft provided by him. Clearly visible changes undertaken on the work in progress suggest an autonomous author. The panel is certainly influenced by the theoretical reflections of the humanists and artists at the court of Urbino. (There are also parallels among the intarsias in the palace). It belongs to class of Spalliera pictures, which were destined from the outset for specific areas of rooms. Embedded, for example, into panelling, they could serve as backing sections of sideboards, benches, beds of state or chests. This branch of decorative painting flourished between around 1475 and 1525. According to recent studies, our painting may have been grouped with two comparable pieces, now in Baltimore and Urbino, in the ceremonial antechamber of the Grand Duke in the Palace of Urbino. It differs from the other pieces in its approach to composition: the room is deserted, yet appears accessible to the beholder.
H.N.

Attributed to Francesco di Giorgio Martini
(1439–1510)
Architectural Veduta,
*c.*1490–1500
Poplar panel, 131 × 233 cm
Acquired 1896
Property of the Kaiser Friedrich Museum Society
Cat. no. 1615

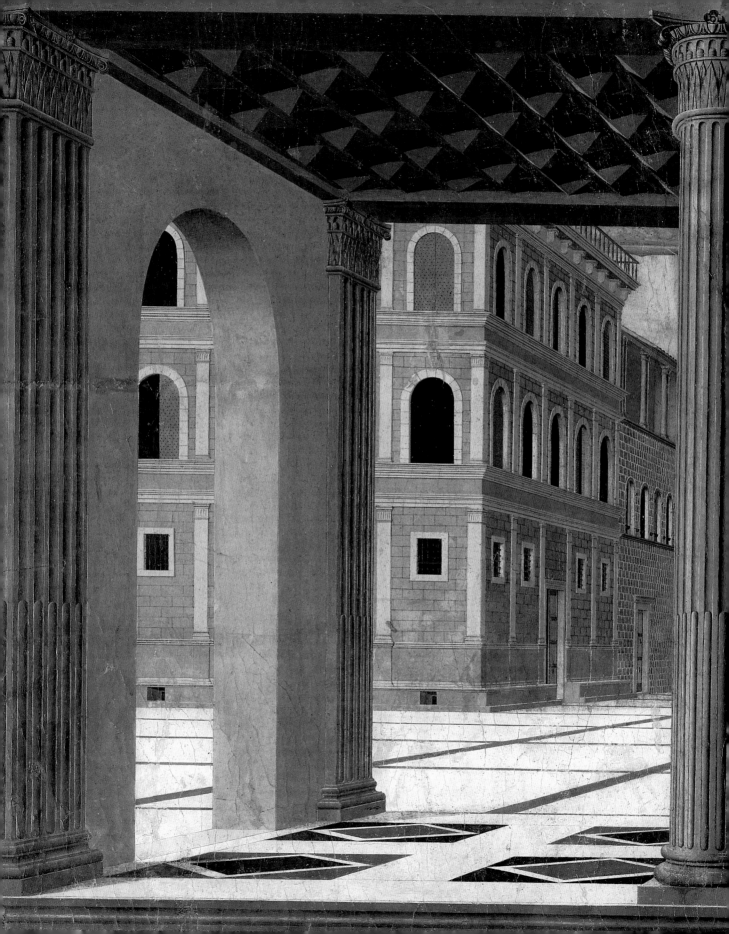

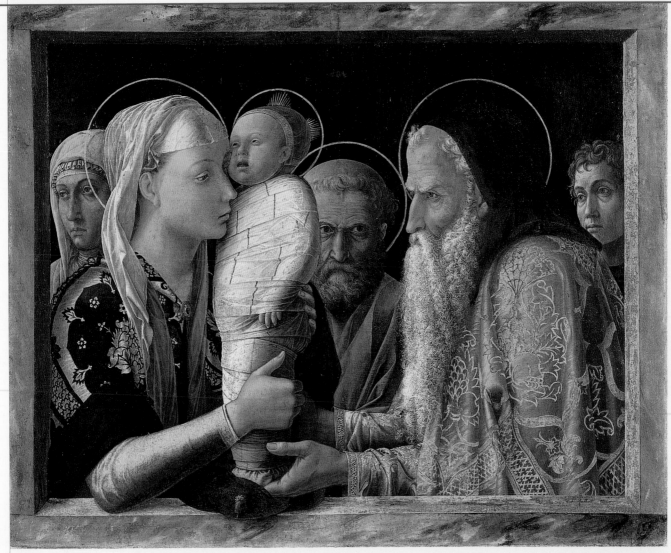

According to Jewish law, a sacrifice had to be made for first-born male children to be exempt from service in the temple. Mary and Joseph were received on this occasion by the aged Simeon, who, according to a revelation, was allowed to die only after meeting the Messiah. Simeon took the child in his arms and presented it to Mary as the long awaited Saviour. Mantegna shows the scene in its quintessence. By omitting description of the location, attention is focused entirely on the dramatic event involving the tightly arranged protagonists – we look at them and nothing else. There are also witnesses in the background of the painting, two marginal figures who do not correspond to the idealised type of biblical character. Research has shown the figure on the right to be Andrea Mantegna, the one on the left is presumably his wife, Nicolosia Bellini. In this earliest example of the inclusion of such a self-portrait of the painter in the circle of saints, the master submitted himself to the mercy of God. For us, this is a testament to his self-confidence.
H.N.

Andrea Mantegna
(1431–1506)
The Presentation of Christ in the Temple, c.1465–6
Canvas, 69 × 86.3 cm
Acquired with the Solly Collection, 1821
Cat. no. 29

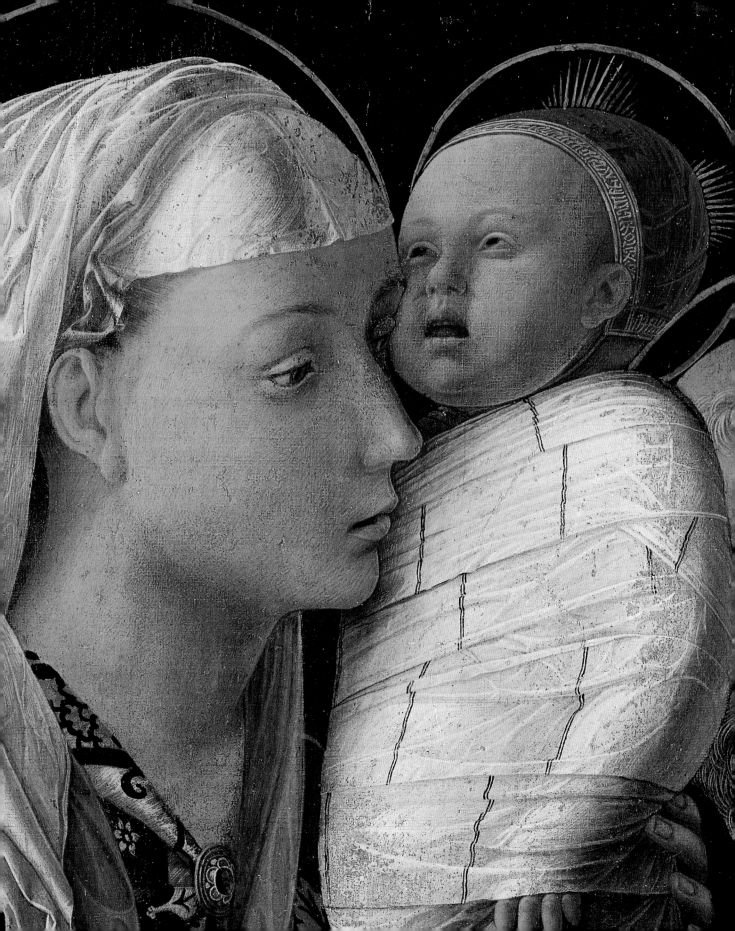

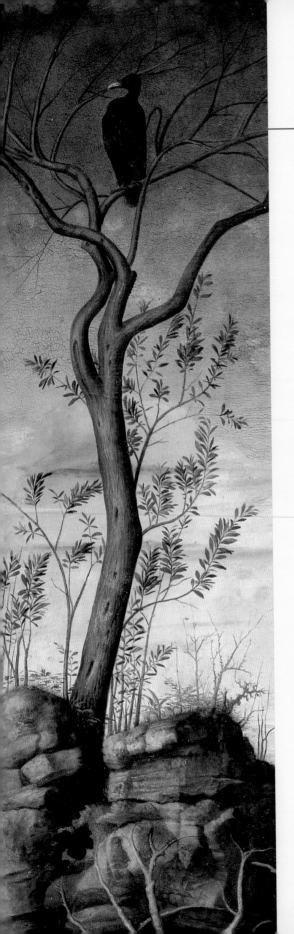

Giovanni Bellini

Giovanni Bellini painted *The Resurrection of Christ* on an altarpiece from the church of the island of San Michele, near Venice, for his patron, Marco Zorzi. The novel work is set in a broad, rigorously structured landscape, which is realistic in its detail. Remarkably, this realism extends to the ambience of dawn, at a time when few masters were paying any attention to atmospheric phenomena. According to the Evangelists, the Resurrection took place in the early morning, unobserved by Roman guards – which is why they were traditionally portrayed as being asleep. Matthew reported frightening simultaneous occurrences. In Bellini's painting, we see sleeping as well as astounded guards. The figure of Christ giving his blessing and holding the flag of victory appears flooded by light; the apostle Paul once spoke of the 'spiritual body' of the resurrected Christ. It is also possible to give it a symbolic interpretation: Jesus was often referred to as the 'Morning Sun' or as the 'Sun of Justice'. The three Marys approach with the intention of anointing the body of Christ. Their goal is the tomb in the foreground, in which the closed sarcophagus may be recognised. However much Bellini strove to depict the concrete, what he describes here is a mystery.
H.N.

Giovanni Bellini
(1430/1–1516)
The Resurrection of Christ,
1479
Canvas (transferred from
poplar panel), 148 × 128 cm
Acquired 1903
Cat. no. 1177A

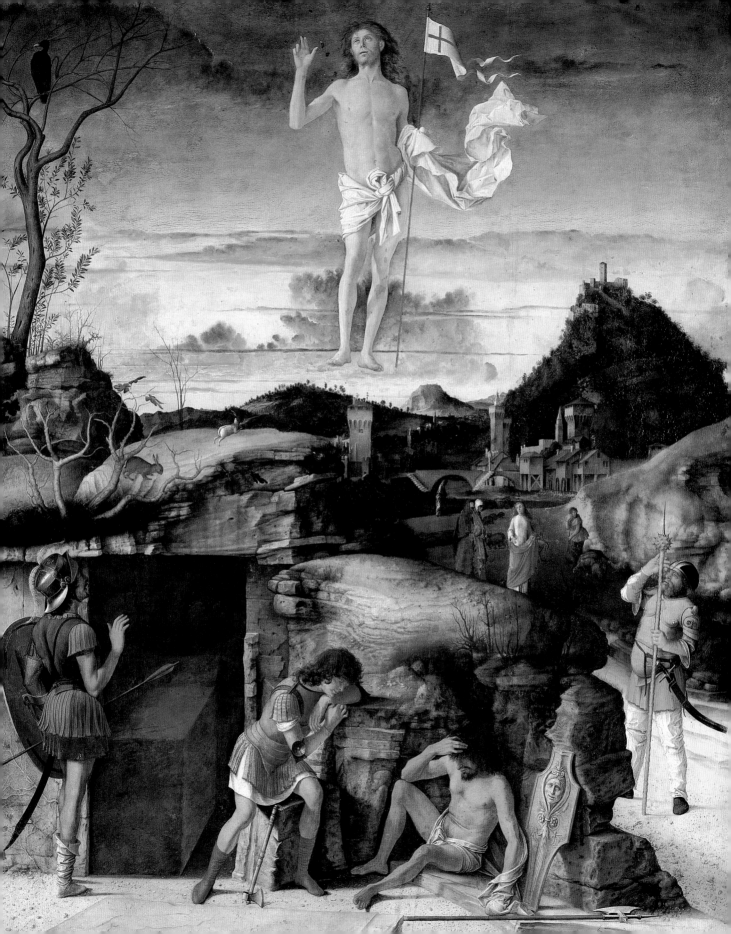

Titian

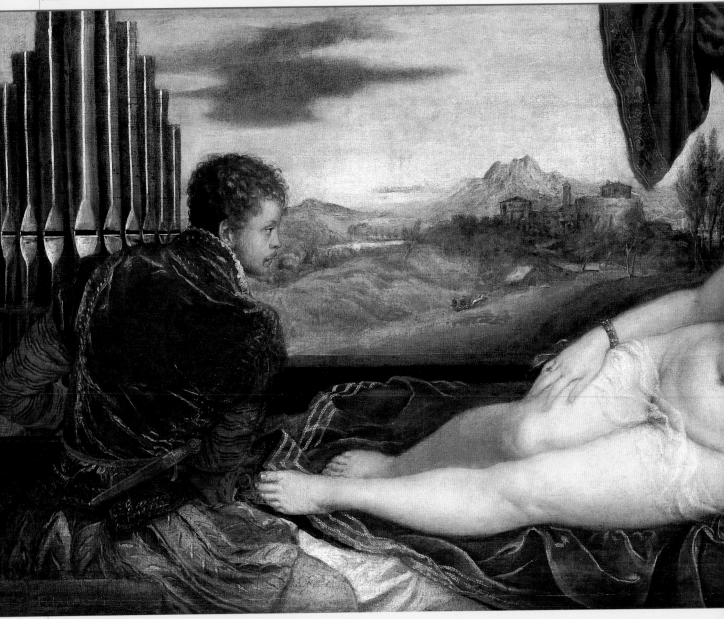

Titian
(1488/90–1576)
Venus with an Organist,
*c.*1550–2
Canvas, 115 × 210 cm
Acquired 1918
Cat. no. 1849

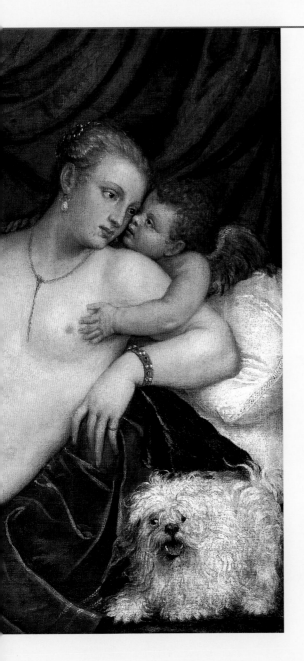

Titian painted a series of iconographically novel images of Venus, showing musicians next to the goddess. The Berlin piece belongs to this series. Links with a version in the Prado are evident. There are, however, considerable differences in composition and detail, for example the Prado painting has a rigorously laid-out garden in the background. In the Berlin painting, by contrast, there is a gently articulated landscape that seems to blend in with the group of figures, enhancing the harmony between the organ player and the female nude by the use of colour and light. Scholars have agreed on neither the dating of the paintings nor their symbolic interpretation. Doubt has been cast on whether it is really Venus who is depicted here – the female figure has been interpreted as a courtesan with the musician as her suitor, while the boy Amor has been granted the role of a mere messenger of love, turning the painting into an erotic genre scene. There is nothing to suggest that this is not the Goddess of Love, however, even if the model may have been a beautiful, sought after *demi-mondaine*. Titian's contemporaries probably recognised the meaning of the scene. Today, all interpretations of the image's content remain conjecture; what is apparent is that the master demonstrated here his reverence of female beauty and of love.
H.N.

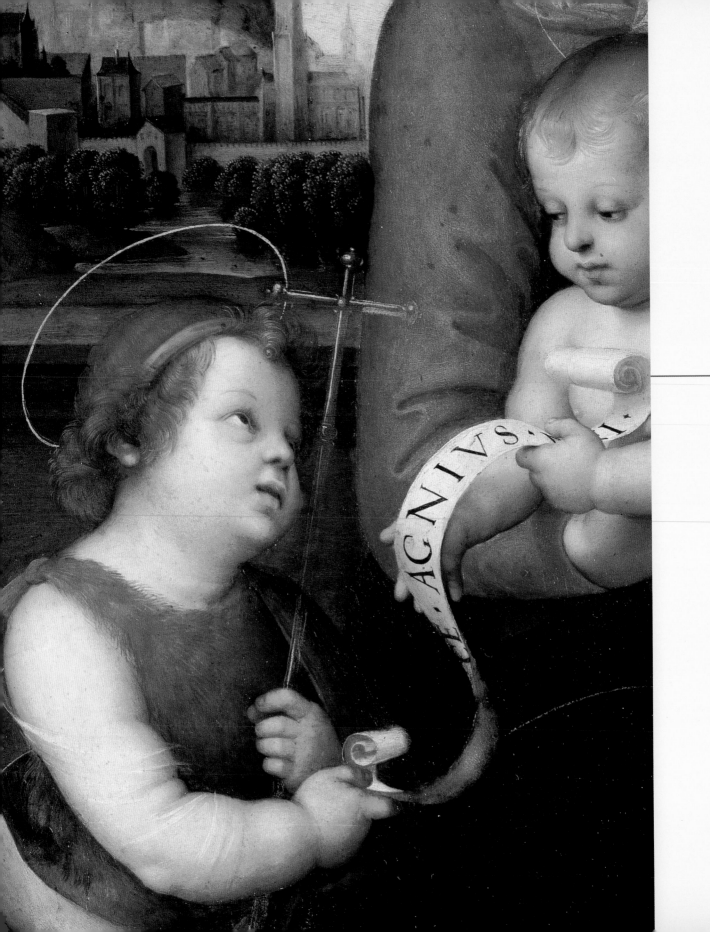

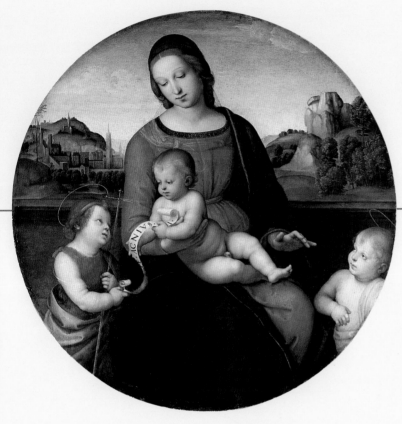

Raphael

This early work by Raphael, once the property of the Genoese-Neapolitan family Terranuova, was almost certainly painted in Florence. In addition to echoes of the Perugia school, scholarship has also established Florentine influences and the artist's first intensive encounters with the ideas of Leonardo da Vinci. A compositional drawing in Lille shows that the pictorial order of the Berlin piece was decisively altered by the inclusion of additional figures and of a landscape background. It thus came closer to fulfilling the requirements of a tondo. The asymmetrical triangular composition, suggesting movement, exhibits special features. The complicated, yet graceful body posture of the Madonna draws attention to the interaction between Jesus and John the Baptist. Both playfully hold a banner inscribed with the quotation from John, 'Behold, the Lamb of God', as a reference to the Passion. Mary accentuates the action by gently holding back a holy child. The latter's gaze is directed at her, the eternally understanding mediator. Like the child, we observe the scene. The bright sky above the landscape fragment emphasises Mary's importance. Here, for the first time, Raphael makes use of a mood in nature: this is a morning light which should be interpreted as a reference to the person of Jesus as the Saviour. H.N.

Raphael
(1483–1520)
Madonna with the Infant Jesus, John the Baptist and a Holy Child (Madonna Terranuova), c.1505
Poplar panel, diameter 88.5 cm
Acquired 1854
Cat. no. 247A

Francesco Melzi

In 1516 Francesco Melzi accompanied Leonardo da Vinci on his last journey to France, where Melzi painted an episode from the Roman poet Ovid's *Metamorphoses*, presumably under the master's instruction. The epic poem was the preferred source of mythological materials. We can view this panel, with its many reminders of works by Leonardo, as an artistic inheritance. It was acquired for the picture gallery in the Palace of Sanssouci at Potsdam. Here it was first attributed to Leonardo, but in 1830, following a comparison with *Flora* in St Petersburg, it was ascribed to Leonardo's pupil Melzi.

The painting shows the Roman guardian of gardens and fruit trees seated under an elm, a vine winding around its trunk. Vertumnus, the God of the Seasons, has transformed himself into an old woman to approach Pomona, and reads this as an allegory of a meaningful community: 'If the tree were standing there, alone, without the vine, he would be sought after only for his leaves. But the vine, too, she rests on the elm tree with which she is entwined. Were they not wed, she would lie low on the ground.' All parts of the painting feature carefully wrought contrasts, juxtaposing or complementing each other. The viewer may see in this an illustration of ideas of a harmonious world order. Following Leonardo, the piece reveals a careful study of nature as well as the highest level of craftsman-like skill. Thanks to the delicacy of his works, Melzi was known as a 'grandissimo miniatore'.

H.N.

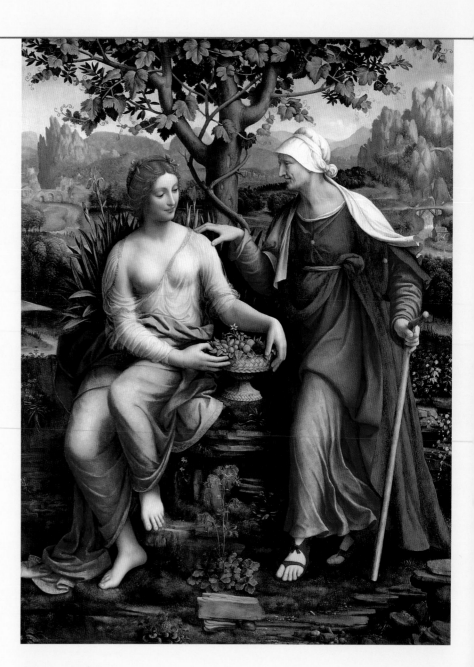

Francesco Melzi
(1493–1570)
Vertumnus and Pomona, c.1518–22
Poplar panel, 186 × 135.5 cm
Acquired from the Royal Palaces
Cat. no. 222

Lorenzo Lotto

This work is signed and dated 1521 on a painted note in the picture's foreground. Together with the flight of arches, the photograph-like, ground-breaking still-life element introduced into this painting emphasises the spatial depth of the picture, within which the Madonna faints upon her last farewell from her Son. Lorenzo Lotto was a mature artist when he created this work for the Bergam-ese Domenico Tassi, whose wife Elisabetta Rota is pictured at the event, kneeling at the lower right. The Venetian painter spent most of his time away from his native city – at Treviso, Bergamo, Rome and, finally, on the Adriatic Coast of the Marches – but he remained active within the sphere of influ-ence of the Venetian Republic. R.C.

Lorenzo Lotto
(c.1480–1556)
Christ Bids Farewell to his Mother, 1521
Canvas, 126 × 99 cm
Acquired with the Solly Collection, 1821
Cat. no. 325

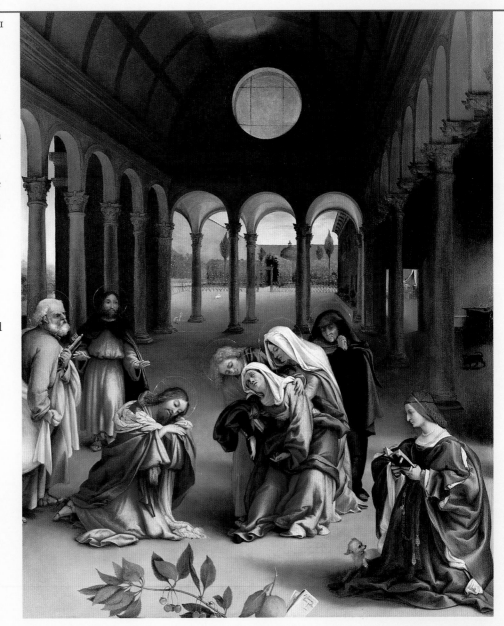

Italian Painting 17th–18th century
German, French and Spanish Painting 17th century

CARAVAGGIO

BERNARDO STROZZI

SEBASTIANO RICCI

GIOVANNI PAOLO PANNINI

ADAM ELSHEIMER

GEORGES DE LA TOUR

NICOLAS POUSSIN

CLAUDE LORRAIN

DIEGO VELÁZQUEZ

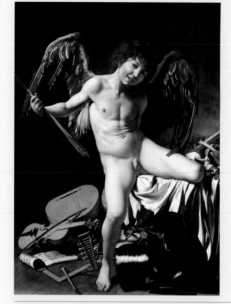

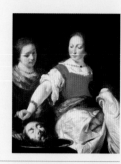

Room XIV

Room XIV

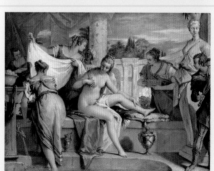

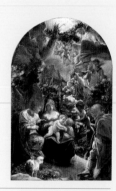

Room 26

Room 24

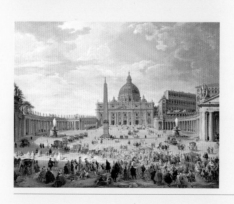

Room 23

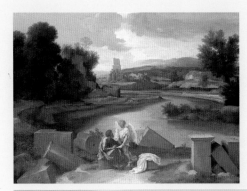
Room 25

Room 26

Room 25

5

Room XIII

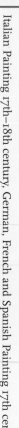

Italian Painting 17th–18th century, German, French and Spanish Painting 17th century

Caravaggio painted this major work for his patron Vincenzo Giustiniani, whose collection was acquired by the Prussian Royal Family in the early 19th century. In the first half of the 17th century, Caravaggio's adversary and biographer Giovanni Baglione wrote an extensive description of the work. The Berlin painting was created at the same time as the revolutionary paintings of the Contarelli Chapel in San Luigi dei Francesi in Rome, that is, at the turn of the century (1599–1600). It shares the same artistic interests: the nude of the mocking street boy – a portrait of Caravaggio's pupil Francesco Boneri – appears three-dimensional in the torsion of the legs and the precociously muscular upper body, the stomach of which the painter reveals fold by fold. The plasticity of the body is further underlined by the light entering from the left. Considerable weight in the dark room is given to the still life of musical instruments and the realistic depiction of the wings. Orazio Gentileschi had lent these to his friend Caravaggio.
R.C.

Caravaggio
(1571–1610)
Amor as Victor, 1601–2
Canvas, 156 × 113 cm
Acquired with the
Giustiniani Collection, 1815
Cat. no. 369

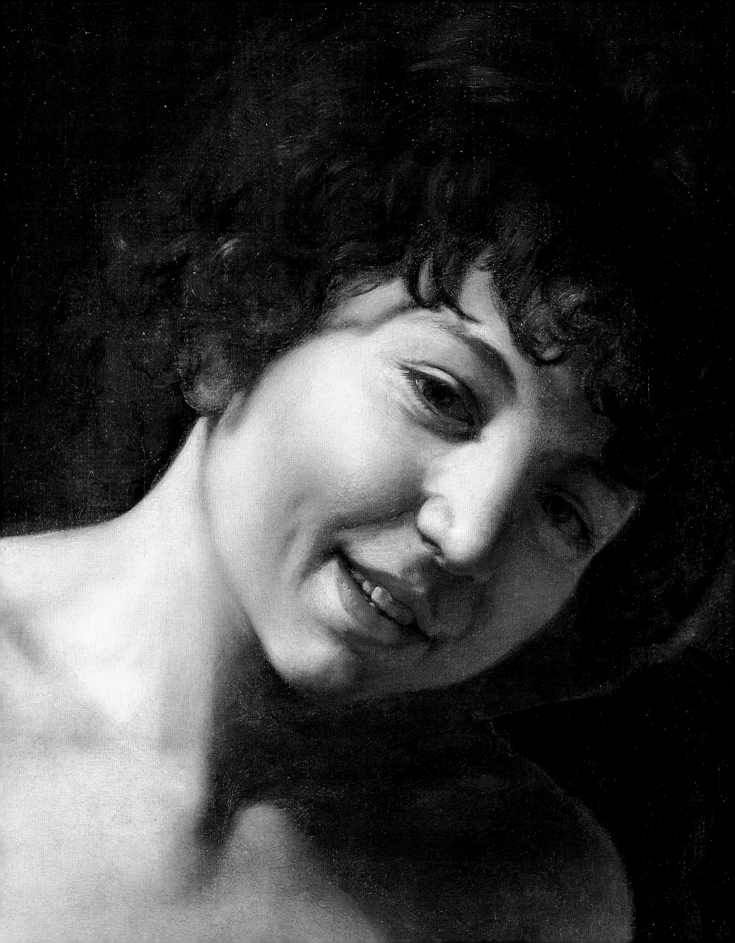

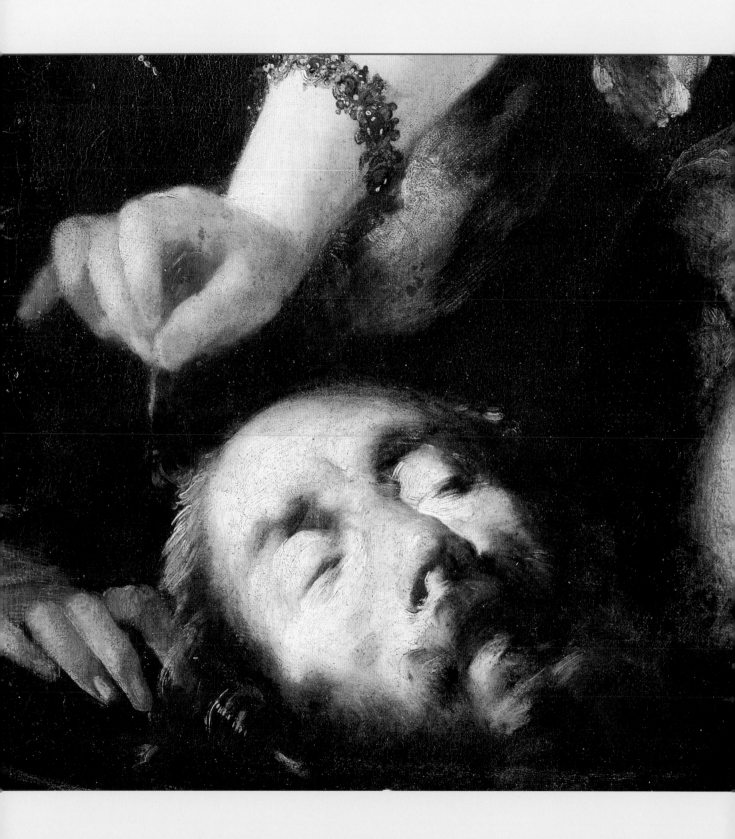

Bernardo Strozzi

This painting – as attractive in coloration as it is repulsive in content – shows Herodias with her daughter Salome, as the latter displays the severed head of John the Baptist on a plate after his execution. This subject, very popular among the followers of Caravaggio, fits easily into Strozzi's repertoire: he makes no secret of his sympathy for the artistic current of naturalism, evident not least in direct quotes from pictures that Caravaggio had painted for Ligurian patrons. The Genoese Capuchin friar developed his style under the influence of Barocci and Vanni with their gentle forms and lively colouring. In 1631, shortly after works such as the Berlin *Salome* were created, he moved to Venice, where he succumbed to the appeal of the colourful magic of classic and contemporary Venetian painting.
R.C.

Bernardo Strozzi
(1581–1644)
Salome with the Head of John the Baptist, c.1630
Canvas, 124 × 94 cm
Acquired 1914
Property of the Kaiser Friedrich Museum Society
Cat. no. 1727

Italian Painting 17th–18th century, German, French and Spanish Painting 17th century

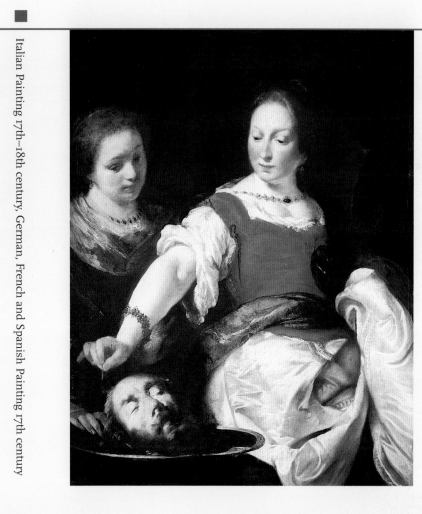

Sebastiano Ricci

Attended by four maids and, on
the far right, a boy with a mirror,
Uriah's beautiful wife, Bathsheba,
devotes herself to her elaborate
toilette in an enclosed garden. The
sight of Bathsheba inflamed King
David's desire and he is usually
depicted in a palace-window in the
background. Here, however, a
maid approaches on the far left
with a letter from the king. The
painting dates from about 1725
and thus belongs to the artist's late
period; its refinement of form and
colour is reminiscent of the golden
age of Venetian painting in the
16th century, in particular of
Veronese. One of the most influ-
ential painters of his time, Ricci
was well on the road to internat-
ional success by the turn of the
17th century. His career took him
to Parma, Bologna, Rome, Milan,
Florence, Venice and London. His
style bridges the impetuous
baroque paintings of Luca
Giordano and the Rococo-like,
Venetian elegance of Tiepolo
R.C.

Sebastiano Ricci
(1659–1734)
Bathsheba Bathing, c.1725
Canvas, 111.8 × 144.3 cm
Acquired from the Royal
Palaces
Cat. no. 454

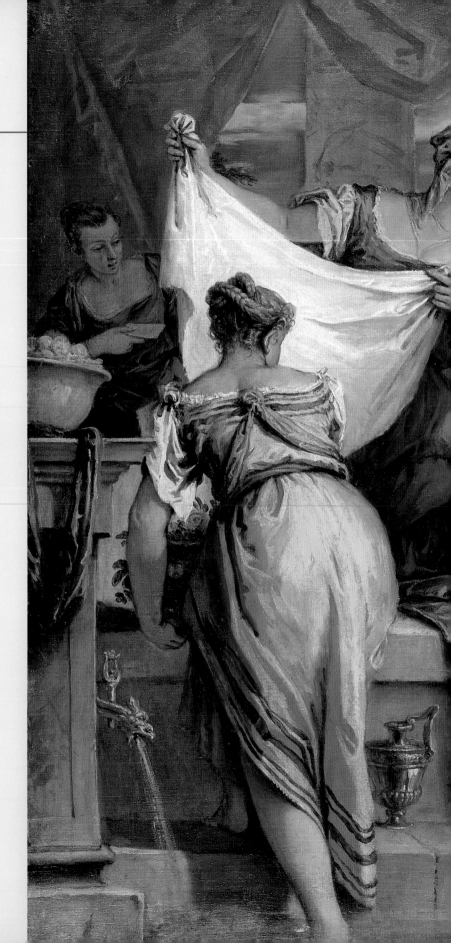

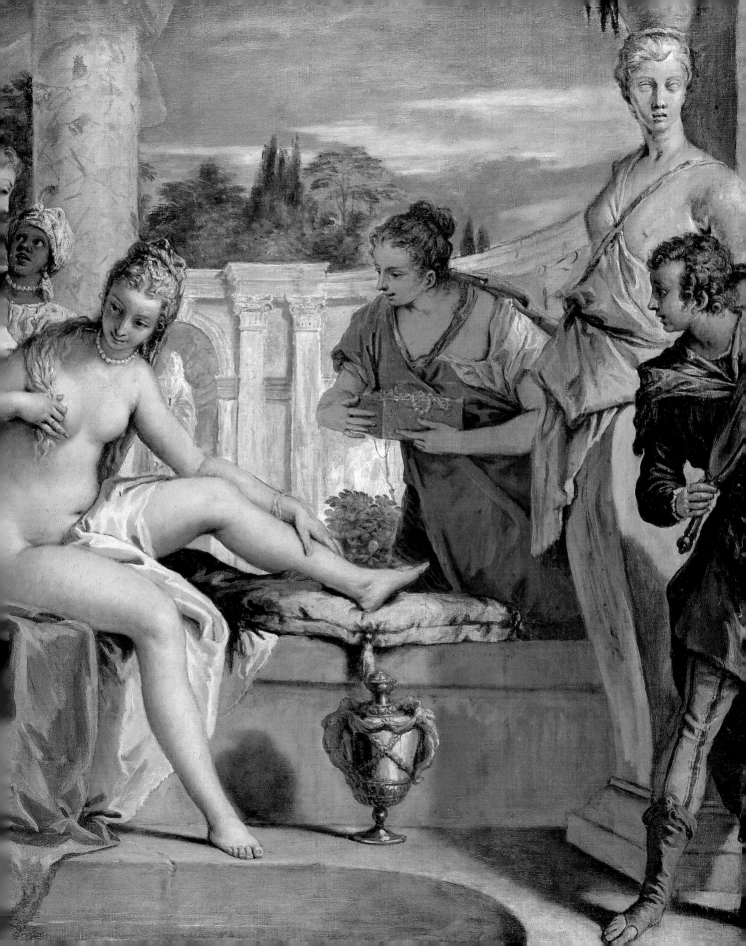

There could be no better example of the
artistic qualities of the famous *vedutisti* of the
18th century than this panoramic view of St
Peter's Square. The square's foreground is
filled by a tightly packed crowd watching the
splendid train of carriages of the new French
Ambassador to the Holy See. The painter's
standpoint is not precisely in the middle of
the square but a little to one side, so that the
right wing of Bernini's colonnade appears
slightly compressed. Documenting the
acceptance of Etienne-François de Choiseul,
later Duc de Choiseul, as ambassador to the
Holy See, the large canvas, signed and dated
1754, also serves as a reminder of an
important event in the history of art. The
duke became an important patron of the
Emilian painter Pannini and of his great
French student, Hubert Robert
R.G.

Giovanni Paolo Pannini
(1691–1765)
*The Departure of the Duc de
Choiseul on St Peter's Square
in Rome*, 1754
Canvas, 152 × 195 cm
Acquired 1980
Cat. no. 80.2

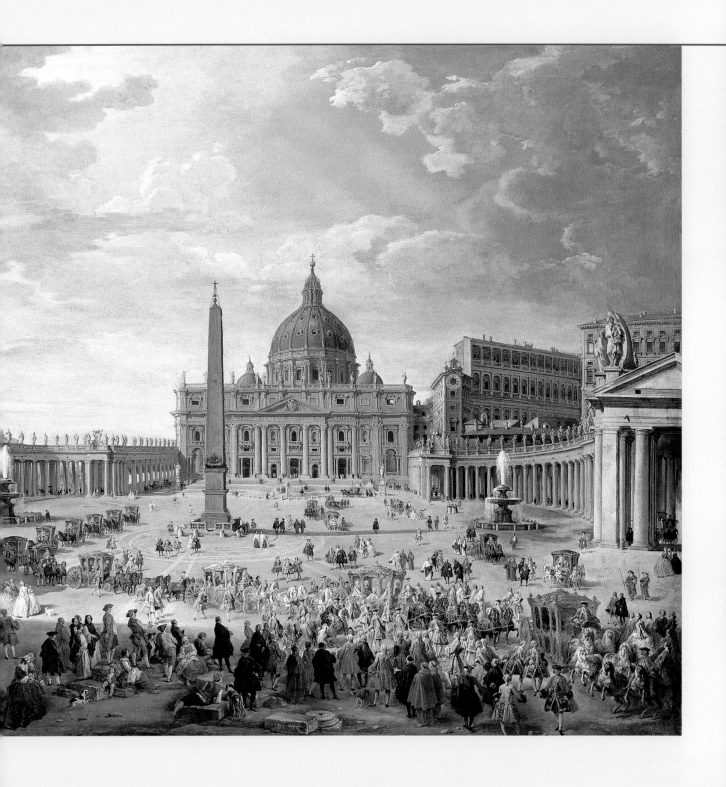

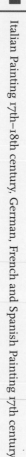

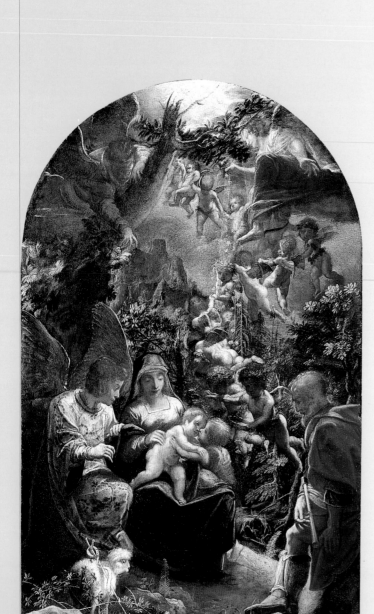

■ Adam Elsheimer

The painter left his native city of Frankfurt in 1598, and possibly spent 1599 in Munich. The following year he crossed the Alps, heading for Venice, which is presumably where he painted the small Berlin copper panel. In this piece, Elsheimer combined two legendary events: The Holy Family resting during the flight to Egypt and the tender reunion of the Christ child with the infant John upon their return. On the left are the Lamb of God with the staff (attribute of the Baptist) and the banner wound around the tree, bearing the words '*Ecce [agnus dei]*' ('Behold [the Lamb of God']. On the right is Joseph the carpenter with his axe. Even thought he has a rightful place in the scene, he has also been formally allocated the function of a *repoussoir* figure, adding a further element to the establishment of depth in the composition. Angels with wreaths and singing praises fill the space of the painting. The fantastic landscape is bathed in a silvery light. The almost old-masterly composition is reminiscent of the paintings of the Danube School (Altdorfer, Cranach the Elder, Huber) which flourished nearly a century before. The painting may have been intended for the private altar of a patron with traditional artistic taste. Perhaps this patron was the Flemish painter Karel Oldraldo, who had been living in Rome since the 1590s and who owned the Berlin copper panel until his death in 1619.
R.M.

Adam Elsheimer
(1578–1610)
The Holy Family with the Infant John and Angels,
c.1599
Oil on copper, 37.5 × 24.3 cm
Acquired 1928
Cat. No. 2039

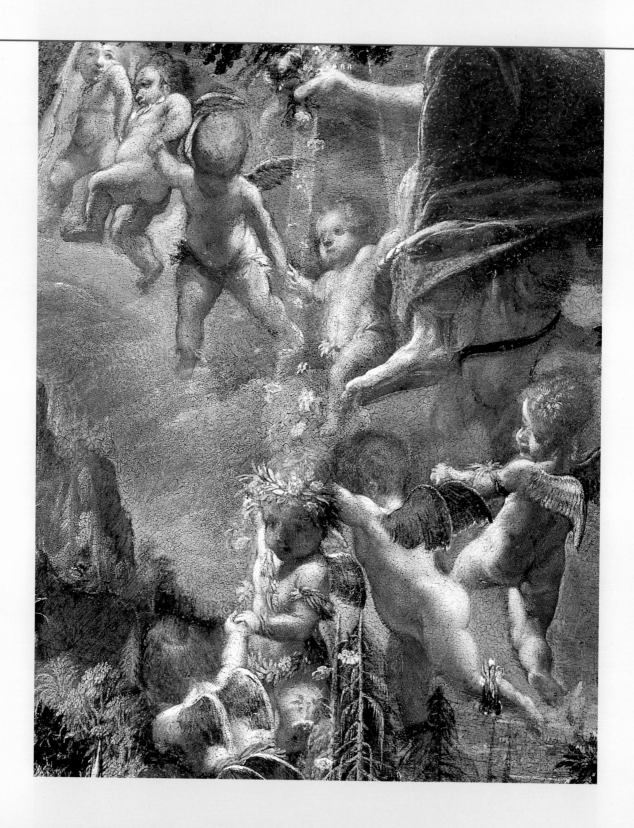

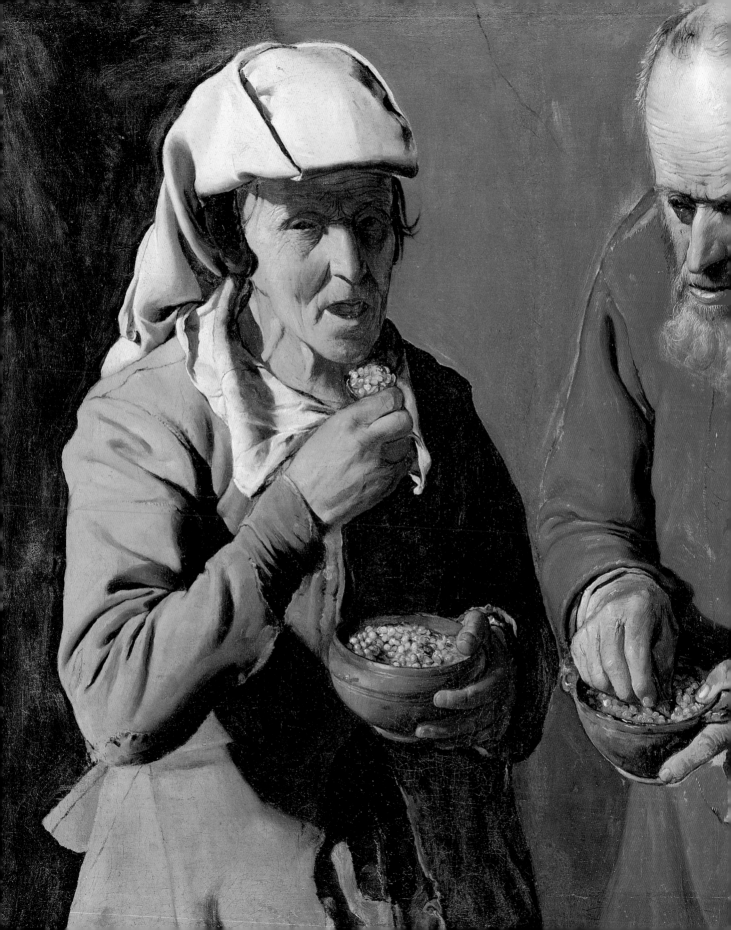

Georges de La Tour

The composition of the picture is emphatically dominated by graphic severity. The saturated local colour is structured by differentiated white highlights. The quasi-sculpted peasant figures, posed with brown bowls and yellow split peas in front of a neutral background, subliminally elevate the representation of the act of eating to the rank of an 'Old Testament scene', thereby simultaneously creating an existential formula of dignity. Georges de La Tour, who came from the harsh landscape of Lorraine and was appointed *peintre ordinaire du Roi* in 1639, preferred compositions that were largely carried by the tense colour contrasts of dark and light. His models were taken from the area bordering the Rhine in the east and the Vosges mountains in the west, a region ravaged in the 17th century by wars, famine and poverty. The graphic works of his countryman Jacques Callot, which provide vivid depictions of the madness of war, may be judged thematically related. The Dutch peasant genre of the 16th and 17th centuries, with its potential for savage mockery, can have been no more than a formal stimulus to La Tour. The painter's sometimes shocking verism may be attributed to a confrontation of some kind with the works of Caravaggio or his followers. The once highly regarded Georges de La Tour fell into oblivion immediately after his death in 1652, and it was not until 1915 that he was rediscovered by art historians.
R.M.

Georges de La Tour
(1593–1652)
*Peasant Couple Eating, c.*1620
Canvas, 74 × 87 cm
Acquired 1976
Cat. no. 76.1

Italian Painting 17th–18th century, German, French and Spanish Painting 17th century

Nicolas Poussin

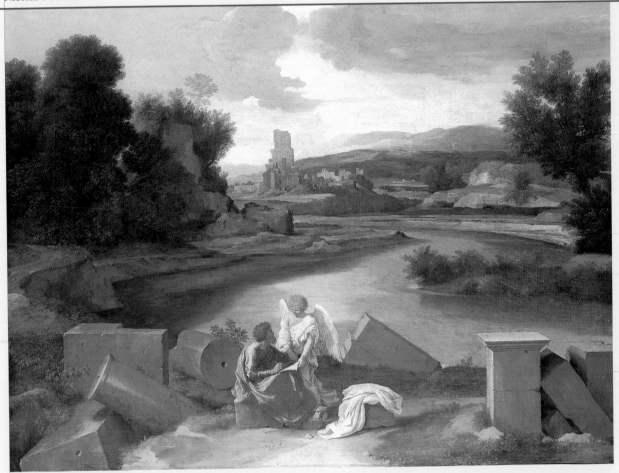

Amidst the calm of the Tiber Valley, the angel dictates the Gospel to St Matthew. The concentrated dialogue is largely carried by the finely differentiated colouring of the group of figures. Their sounding chamber is constituted by unworked column cylinders with joint-holes for connecting links, architrave, ashlar material and, in the background, ruins and groups of trees with heavy clusters of foliage. Of course, we also find here accompanying mythical tales, a bow to the baroque's almost Romantic predilection for visible evidence of a distant past. On the other hand, this ideal, solemn landscape can also be read as a historic triumph of Christianity. Poussin originally came from Normandy, but preferred to live in Rome. As a strict classicist, he always subordinated the discreet local colouring to the drawing. Like Raphael, whom he deeply admired, Poussin regularly took part in excavations in the Eternal City. The Berlin painting was acquired in 1640 by Cardinal Francesco Barberini – together with the *Landscape with John on Patmos*, also by Poussin (The Art Institute, Chicago) – from the artist's studio on the Via Paolina.
R.M.

Nicolas Poussin
(1594–1665)
Landscape with the Evangelist Matthew, 1640
Canvas, 99 × 135 cm
Acquired 1873
Cat. no. 478A

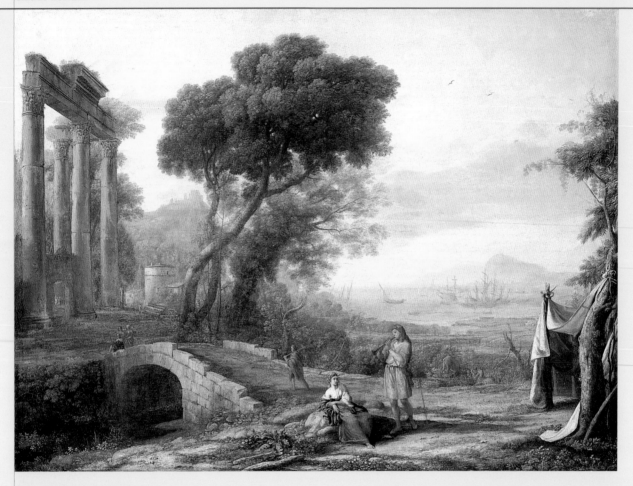

Claude Lorrain, who was originally from eastern France, lived almost exclusively in Rome. That the impressive ruins of that venerable city had a considerable impact on his work can be seen in *Italian Coastal Scene in the Morning Light*. The low horizon fills the extensive space of the picture with a dusky light. A pair of shepherds, cast primarily in red, blue and yellow, are the dominant element of the foreground. X-rays have revealed that these figures originally had a different appearance, and it is still possible to recognise the outline of a stick to the left of the flute-playing shepherd. On the left are the columns of a temple ruin; further back, rural Italian architecture. The groups of trees are composed picturesquely. Like a motif for yearning, unrigged ships are moored in the bay in the background. Everything in the picture rests impassively in itself. Wilhelm von Bode acquired the painting for the Gallery in Paris.
R.M.

Claude Lorrain
(1600–82)
Italian Coastal Scene in the Morning Light. 1642
Canvas, 97 × 131 cm
Acquired 1881
Cat. no. 448B

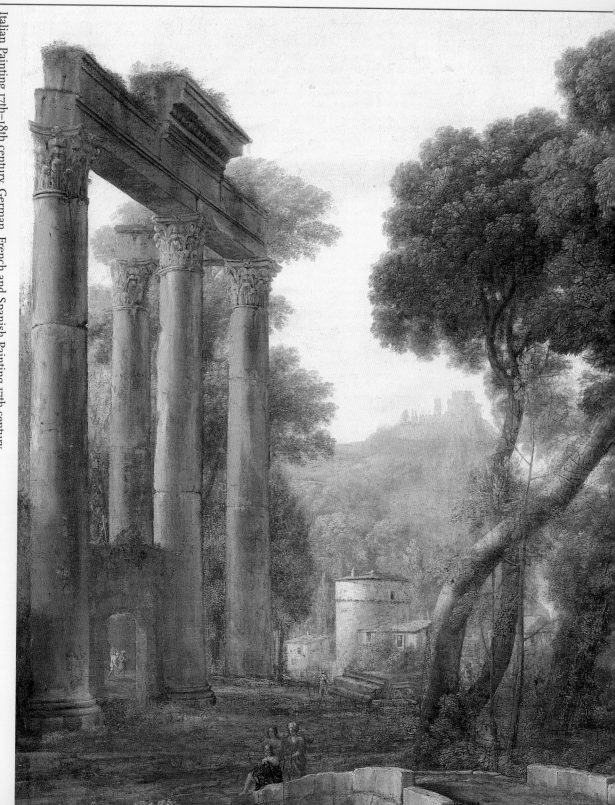

Italian Painting 17th–18th century, German, French and Spanish Painting 17th century

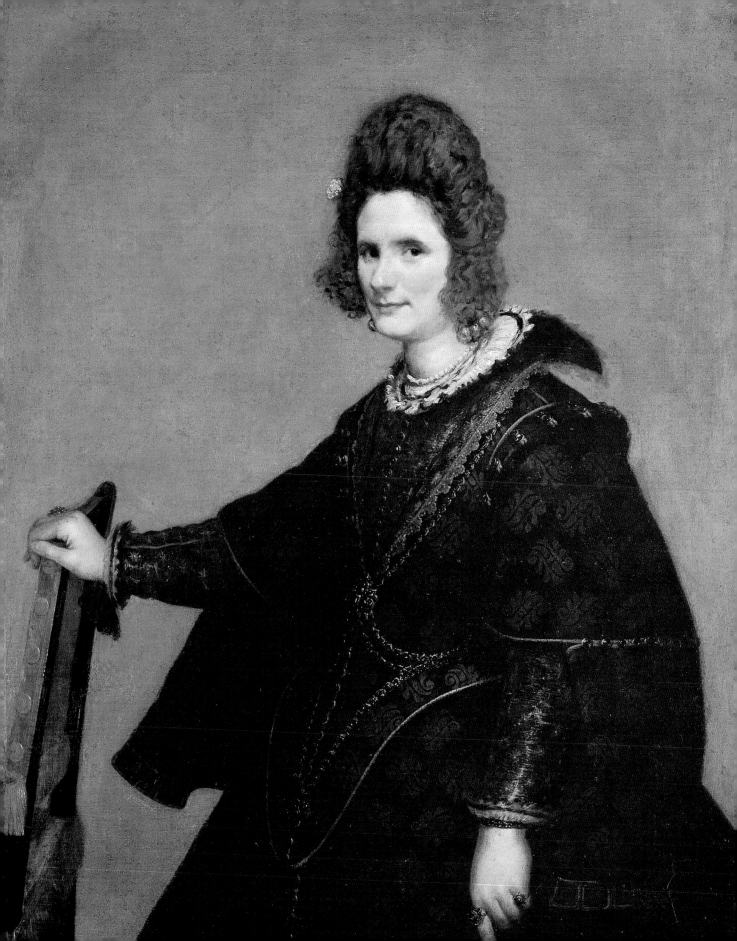

Diego Velázquez

The model, portrayed in three-quarter view with her arm stretched out to rest on the back of a chair, was once identified as the painter's wife, Juana Pacheca, because the reverse of the canvas bears the inscription 'Juana Miranda'. However, the lady in question is probably Dona Leonora de Guzman, Countess of Monterrey and wife of the Spanish Ambassador to Rome (1628–31), later Viceroy of Naples (1631–7). Accordingly, it can be assumed that the painting dates from the artist's first stay in Rome (1629–30) or shortly afterwards, although it is quite unlikely that Velázquez would not have worked from life. While some scholars doubt that this painting is entirely Velázquez' work and assume that assistants contributed to its execution, the psychological sensitivity with which the model's frame of mind – dignified, yet marked by melancholy or perhaps reserve – has been captured, should be noted. Furthermore, the masterful brushstrokes – worthy of Titian – in the aristocratic lady's dark dress fabric and in the velvet of the chair cover in front of the bare background, as well as the gentle colour transitions in a scene bathed in bright natural light, are evidence of a hand of such a sure tactile sense that it cannot have belonged to anyone other than the Spanish genius.
R.C.

Diego Velázquez
(1599–1660)
*Portrait of a Lady, c.*1629–30
Canvas, 123.7 × 101.7 cm
Acquired 1887
Cat. no. 413E

Italian Painting 17th–18th century, German, French and Spanish Painting 17th century

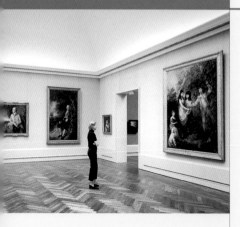

ANTOINE WATTEAU

ANNA VALLAYER-COSTER

NICOLAS DE LARGILLIERRE

SIR JOSHUA REYNOLDS

THOMAS GAINSBOROUGH

ANTOINE PESNE

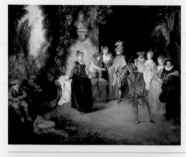

Room 21

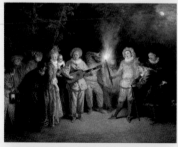

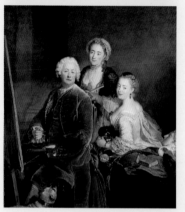

Room 22

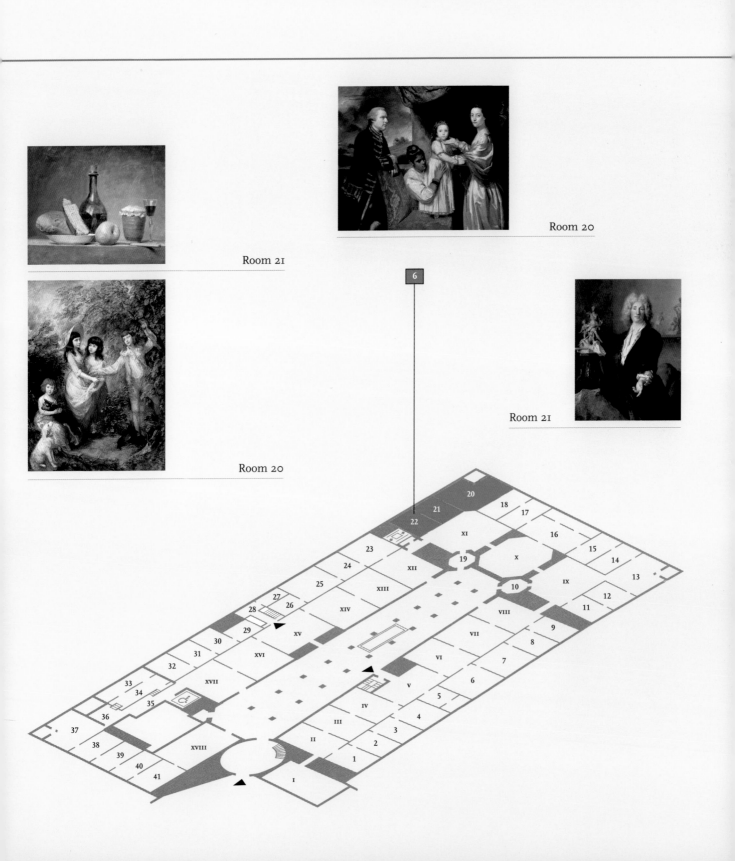

Room 20

Room 21

6

Room 21

Room 20

Antoine Watteau

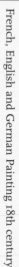

These Berlin pseudo-counterparts
have long been associated with
each other by way of print repro-
ductions of 1734, which gave them
their titles. In *The French Comedy*
Bacchus toasts the noble hunter
Amor. Colombine, personification
of the folly of love, supports the
pact. In front of this allegoric
setting, a couple hesitatingly begins
its dance. *The Italian Comedy*,
Watteau's only nocturnal piece, is
dominated by Pierrot with a guitar
and Mezzetine with a torch. On the
left, Colombine appears again,
holding a mask. Watteau's pictorial
choices, situated thematically on
the narrow border between illusion
and reality, are full of riddles.
Frederick the Great acquired both
these paintings before 1769.
R.M.

Antoine Watteau
(1684–1721)
The French Comedy
The Italian Comedy
After 1716(?)
Canvas, each 37 × 48 cm
Acquired 1829
Cat. nos 468, 470

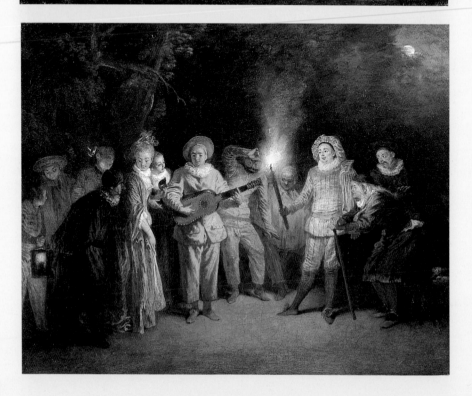

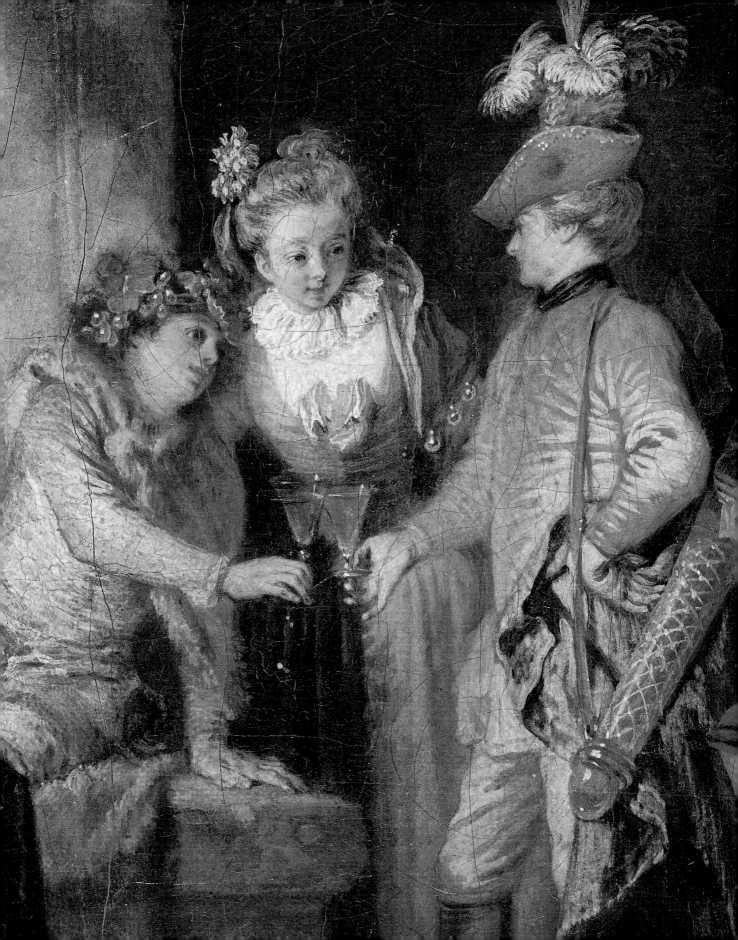

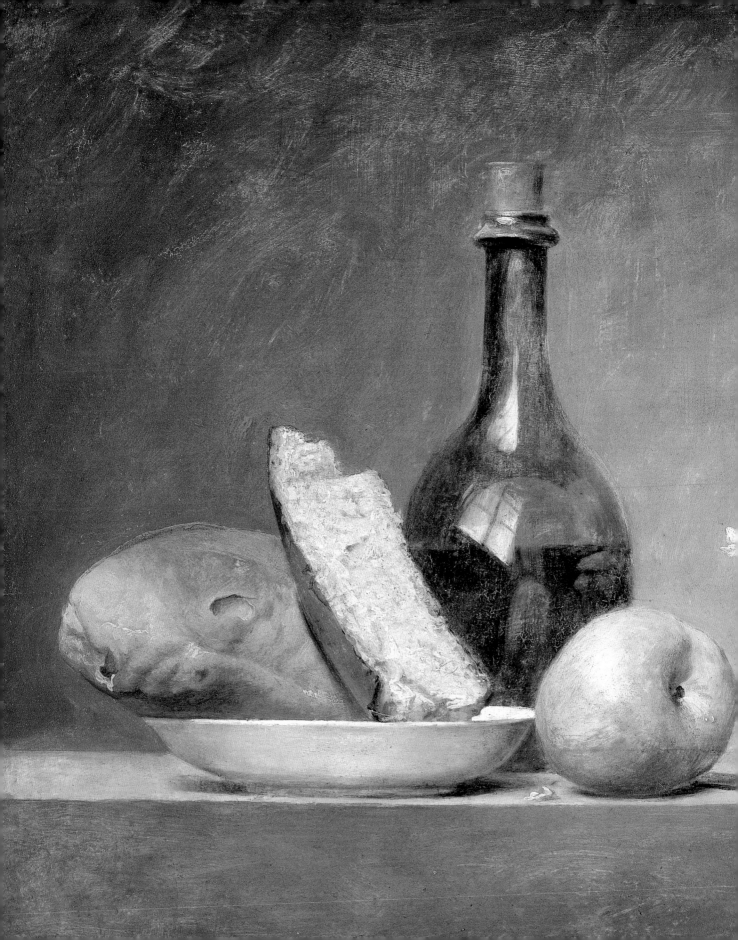

French, English and German Painting 18th century

The objects are arranged in strict pyramidal order before a grey background. A plate with a broken loaf of bread links up to the upright rounded bottle, in which the artists' studio window is reflected. Apple, pot of jam and narrow wine glass form an imaginary triangle. On the right, the knife protruding over the stone sill skilfully interrupts the painting's tectonics. The contrasting materials are aptly portrayed. The artist was of course familiar with the works of her Parisian contemporary Chardin. In contrast to his atmospheric coloration, she used brighter colours to achieve a decorative effect. As a member of the Royal Academy of the Arts, the artist had a studio in the Louvre. She brought to a close the great tradition of French still-life painting of the *dixhuitième siècle*.
R.M.

Anne Vallayer-Coster
(1744–1818)
Still Life with a Bottle
Oak panel, 27.5 × 32.5 cm
Acquired as a gift from
J. Boehler, 1915
Cat. no. 1731

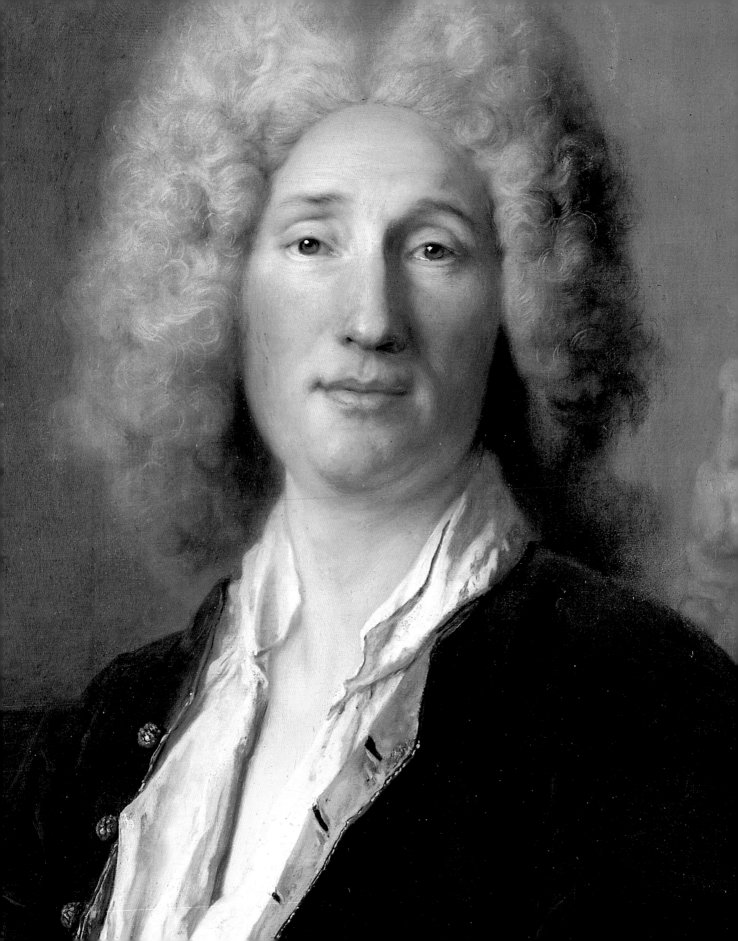

Nicolas de Largillierre

The sculptor cleverly presents himself between unshaped material in the left foreground of the picture and completed work, exemplified by the *Torso of Belvedere* and the *Antinous* from the same Vatican collection of sculptures, in the background. As a stipendiary of the French Academy of the Arts, Coustou lived in Rome between 1683 and 1686. There he had the opportunity to internalise the contemporary canon, which demanded a programmatic orientation to Hellenic and Roman Imperial art. In the light of this ideal, the creative process celebrated here manifests itself in *Spring*, a group of figures that Coustou created around 1712 for the garden façade of the now demolished Hôtel des Noailles in Paris. The sculptor's works decorated Parisian churches and gardens as well as the palaces in Versailles, Trianon and Marly. The colouring and composition of the painting provide a characteristic example of art at the end of the reign of Louis XIV.
R.M.

Nicolas de Largillierre
(1656–1746)
The Sculptor Nicolas Coustou in his Studio, c.1710–12
Canvas, 135.5 × 109.2 cm
Acquired 1980
Cat. no 80.1

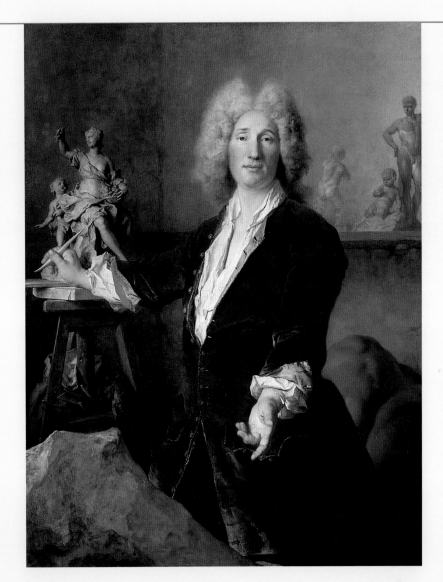

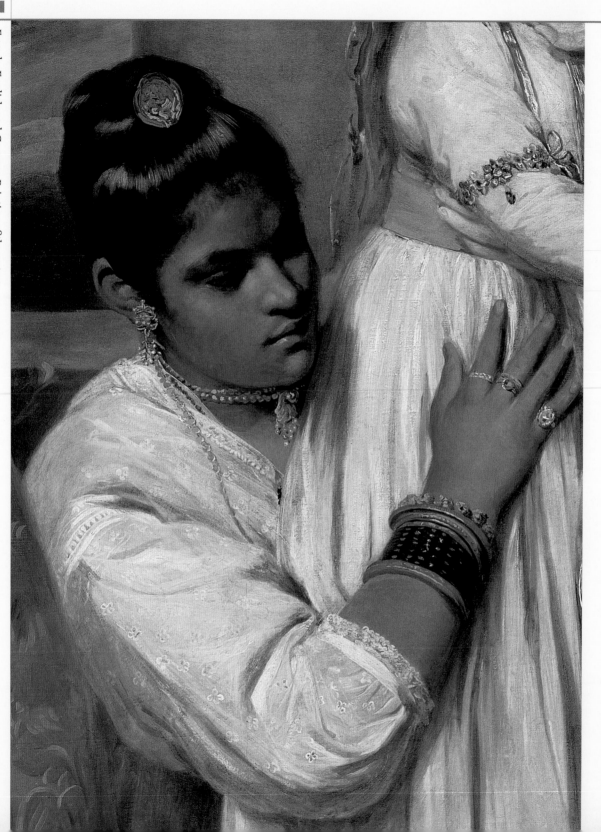

Sir Joshua Reynolds

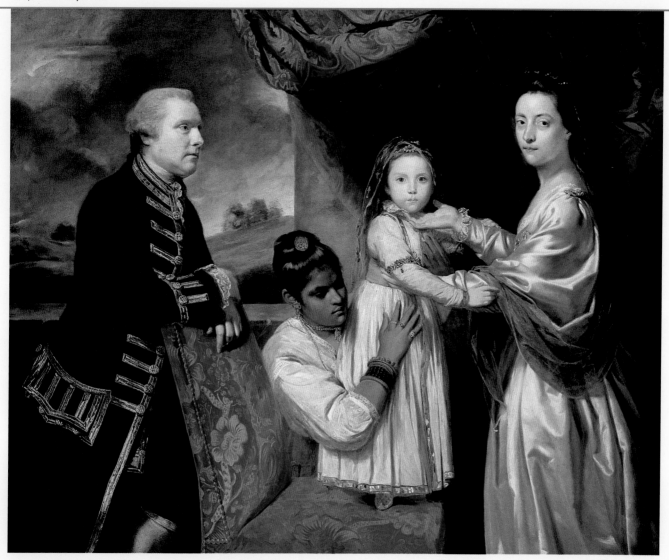

George Clive returned home from the English Crown's Indian campaign a wealthy man. In 1763 he married Sidney Bolton, pictured here. Their daughter, born in 1764, died young. She is presented here supported in an oddly cautious manner by her mother and the maid. The left third of the painting was added later, at which point the landscape behind the Indian woman was overpainted. This alteration may have been motivated by the death of the child, because now the family remained united as in an epitaph picture. X-rays have revealed, for example, that Reynolds completed only the wife's face and sketched her dress in just a few brush strokes. The final execution was probably carried out by the workshop manager Peter Toms. Here the studio of the President of the Royal Academy managed once more to lend formulae of dignity to the portraits through strict treatment of contours.

R.M.

Sir Joshua Reynolds
(1723–92)
George Clive and his Family with an Indian Servant,
c.1765–6
Canvas, 140.8 × 173.7 cm
Acquired 1978
Cat. no. 78.1

Thomas Gainsborough

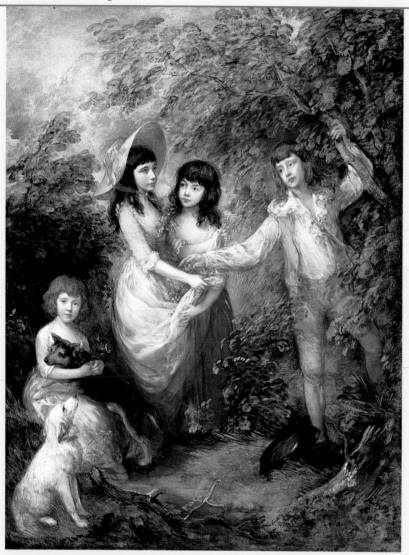

Thomas Gainsborough
(1727–88)
The Marsham Children, 1787
Canvas, 242.9 × 81.9 cm
Acquired 1982
Cat. no. 82.4

In 1787, Charles Marsham, the first Earl of Romney, commissioned the highly regarded Gainsborough to paint this life-size portrait of his children, Amelia Charlotte, Frances, Harriet and Charles. The artist integrated the figures into the landscape in a characteristic manner – the step by step modelling of the composition remains evident in the colouration. This feature is characteristic of Gainsborough's work and was defended by the artist in written comments to his contemporaries.

Despite the ostentatious informality, the subjects in this scene of hazelnut-picking are only formally brought together. It is only with an effort that their eyes meet, so that ultimately the depiction lacks a sense of internal coherence. It is evident that Gainsborough inserted the children's faces in the painting after separate portrait sittings. The seemingly spontaneous painting is in fact the product of considered studio planning. Thus this wonderful late work of Gainsborough lacks the detachment of official aristocratic portraits, but retains their formula of dignity.

R.M.

French, English and German Painting 18th century

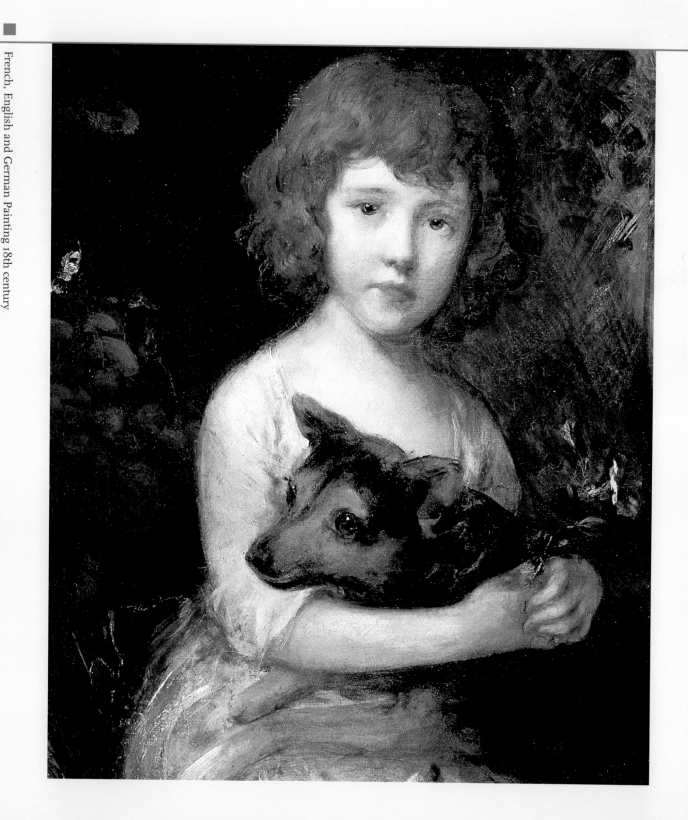

Antoine Pesne

The Prussian court painter portrays himself here in a moment of interrupted activity. The group is arranged in an imaginary triangle, balancing the composition. The proximity of the three figures is intended to illustrate their close relation to each other. Like inspiring muses, the daughters show an interest in their father's work. On the right margin of the painting there can be discerned two books, one of which can be identified from the inscription on its spine as Ovid's *Metamorphoses*. This Classical poem often served the painter with its themes. The volume rests on a light blue sheet of paper with a chalk drawing depicting Venus and Amor. Next to it can be seen a cast of the bust of a statue of Apollo, leader of the muses. Warm colours are juxtaposed to occasionally pastel-like shades. This kind of coloration dominated Pesne's paintings, which played a decisive role in shaping Frederician Rococo after 1740. The self-portrait was probably painted in Pesne's studio on Friedrichswerder in Berlin.
R.M.

Antoine Pesne
(1683–1757)
*Self-portrait with Daughters
Henriette Joyard and Marie de Rège
in Front of an Easel*, 1754
Canvas, 179.4 × 151.2 cm
Acquired 1903
Cat. no. 496B

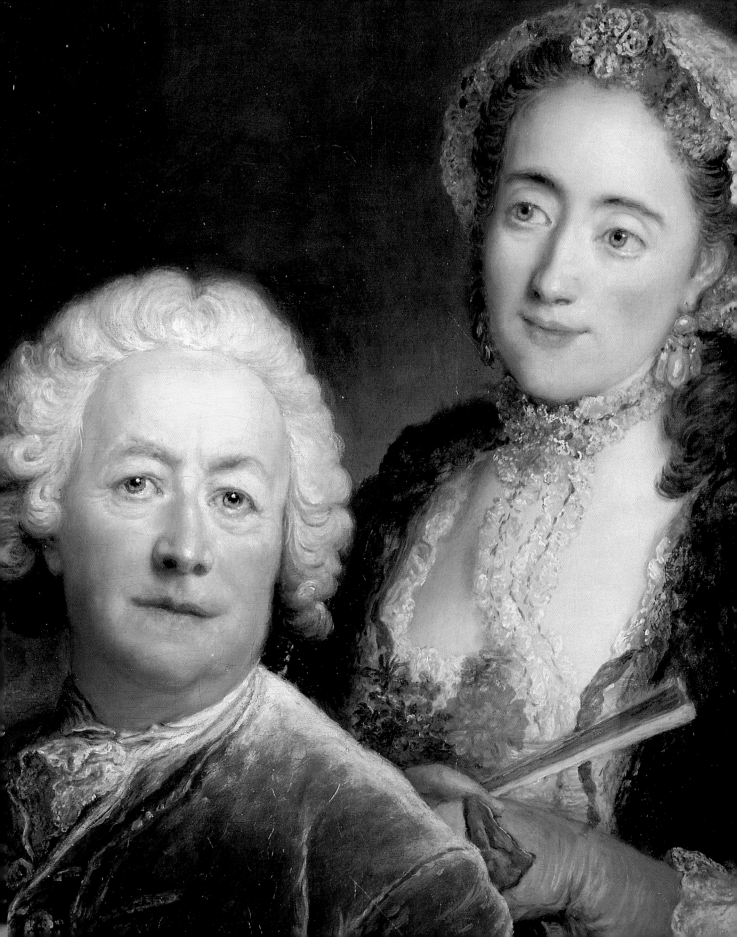

The Bee WHO Loved Words

For my mum, Ann (the original spelling bee) – H.D.

For Silas, one of a kind xx – E.S.

PUFFIN BOOKS

UK | USA | Canada | Ireland | Australia | India | New Zealand | South Africa

Puffin Books is part of the Penguin Random House group of companies whose
addresses can be found at global.penguinrandomhouse.com.

www.penguin.co.uk
www.puffin.co.uk
www.ladybird.co.uk

Penguin
Random House
UK

First published 2023

001

Text copyright © Helen Docherty, 2023
Illustrations copyright © Erica Salcedo, 2023

The moral right of the author and illustrator has been asserted

Printed in China

A CIP catalogue record for this book is available from the British Library

ISBN: 978–0–241–45068–0

All correspondence to:
Puffin Books, Penguin Random House Children's
One Embassy Gardens, 8 Viaduct Gardens, London SW11 7BW

MIX
Paper from
responsible sources
FSC® C018179

The Bee WHO Loved Words

Helen Docherty & Erica Salcedo

PUFFIN

This is the tale of a very small bee
with a very long name: Per-*seph*-on-e.

The other bees' names were short and sweet,
like *Daisy*, *Lily*, *Rose* and *Pete* . . .

But Persephone's
name buzzed round her head.

While the other bees all slept sound in bed,
Persephone stayed up late at night –
determined to learn to spell it right.

But she didn't stop there.
All year through,
Persephone's word collection grew.

ASTRONAUT

and TELESCOPE

Rhinoceros

KALEIDOSCOPE

Nothing gave her greater pleasure.
Each word was like a secret treasure.

pterodactyl

saxophone

POMEGRANATE

xylophone

She wrote on stones, on shells, wherever . . .
And everyone said, "Wow, isn't she clever?"

Except for . . .

. . . the Queen, Hermione,
who wanted a *word* with Persephone.

"This writing thing is all very well . . .
but a bee's main task is NOT to spell!

Your job is to look for flowers, my dear."
She smiled. "I hope I've made that clear.
Now fly along quick, and pollinate –
and make sure you don't get home too late."

But Persephone knew that words have power.

Some are sweet . . .

I LOVE YOU

. . . and some are sour.

Keep out! No games

Private!

Let other bees look
for flower juice –

she wanted to put her
words to use!

"I've lost my toy,"
 a butterfly sighed.

"*I'll* help you find it!"
 Persephone cried.

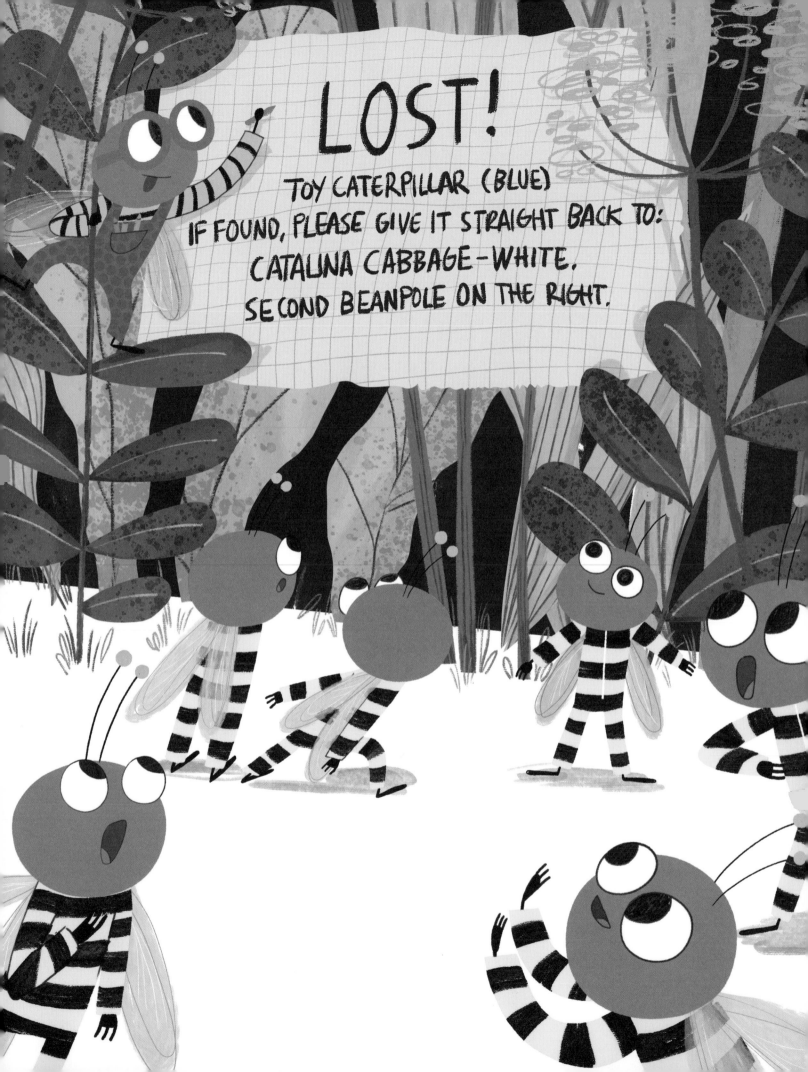

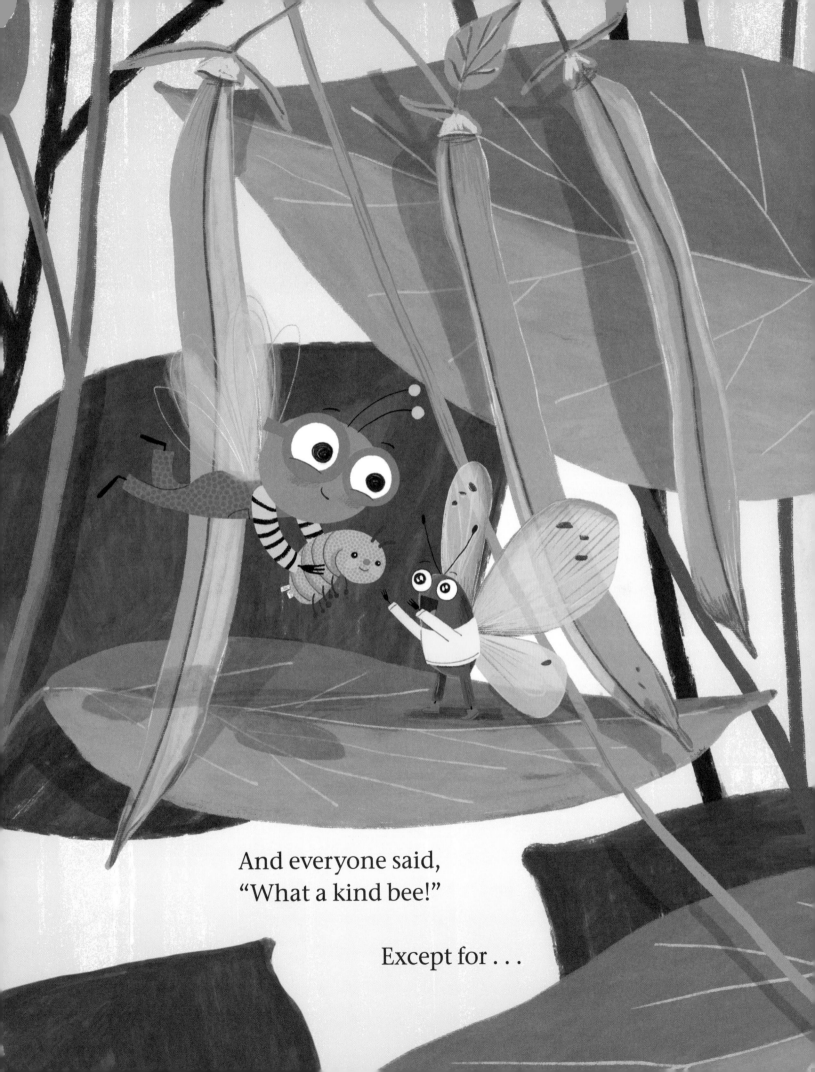

And everyone said,
"What a kind bee!"

Except for . . .

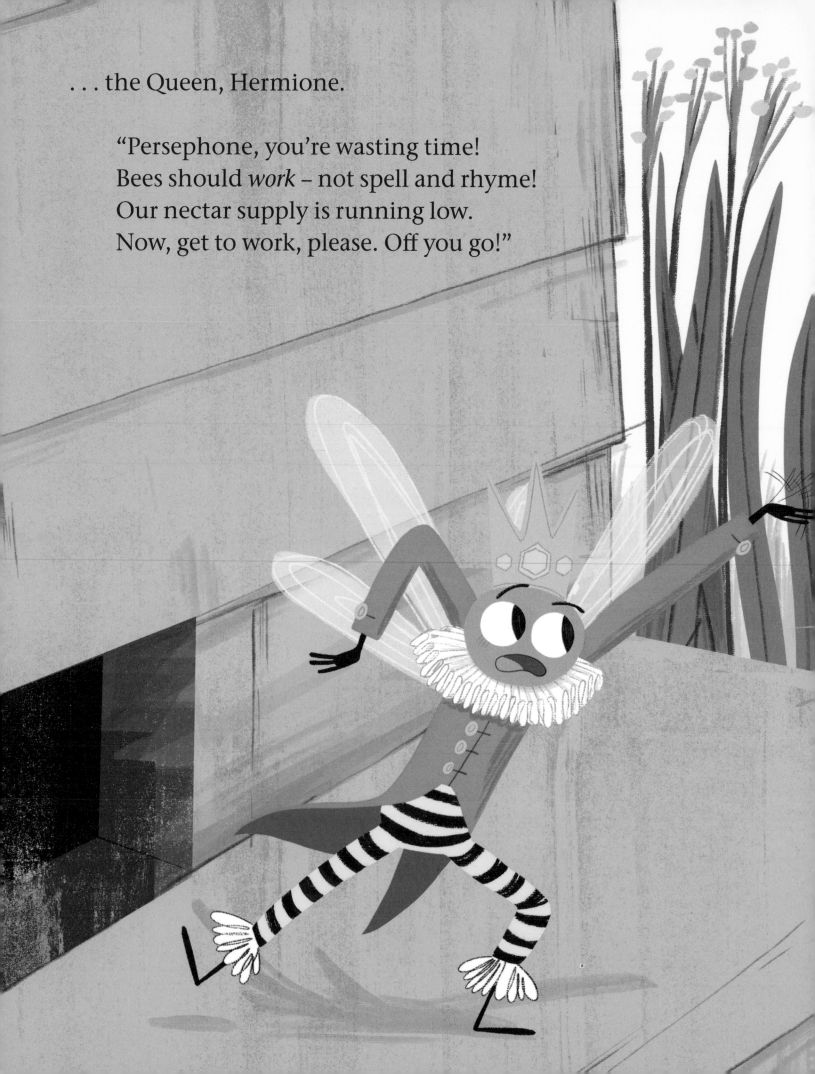

. . . the Queen, Hermione.

"Persephone, you're wasting time!
Bees should *work* – not spell and rhyme!
Our nectar supply is running low.
Now, get to work, please. Off you go!"

Persephone sighed,
and off she flew.

She had more important things to do.
Like warning her friends when to stay away,

and writing the script for a garden play.

And everyone said, "What a brilliant bee!"

Except for . . .

. . . the Queen, Hermione.

"Persephone, when will you ever learn?"
The Queen had never looked so stern.

"Your words have caused a big distraction –
precisely when we need more ACTION!
We have to work harder than before;
there aren't enough flowers any more.
And *we're* in danger – haven't you heard?

You are not to write another word!"

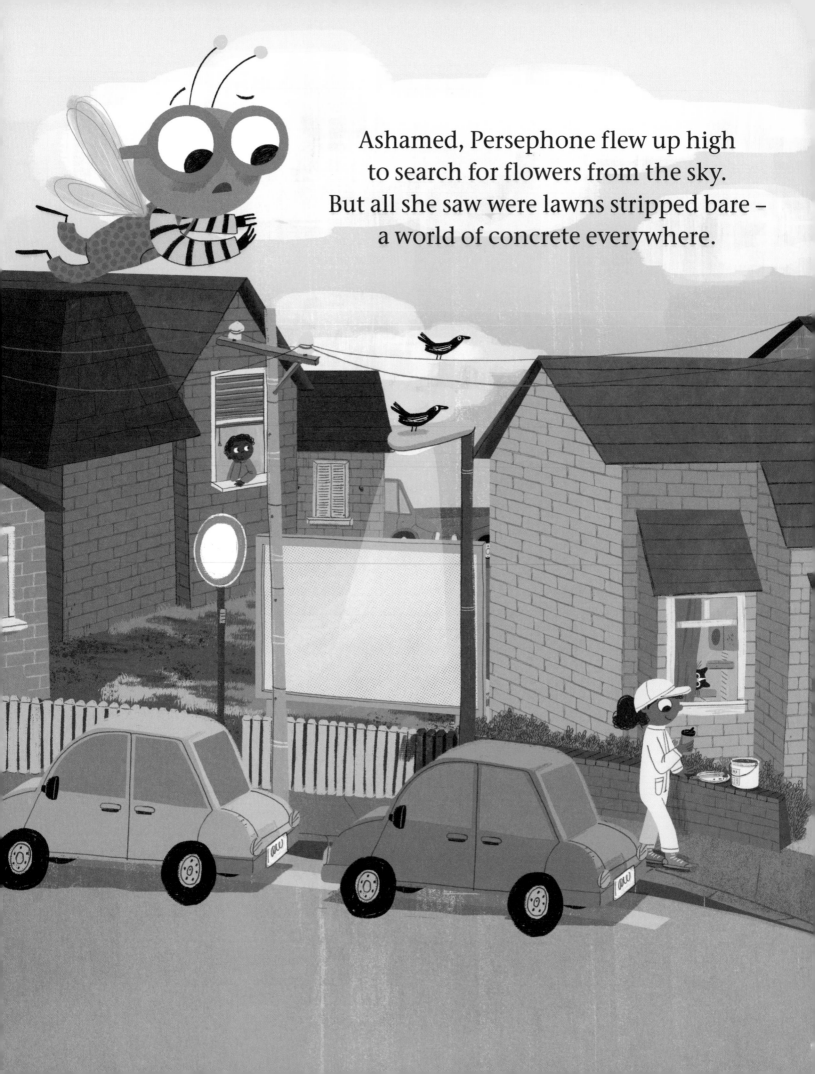

Ashamed, Persephone flew up high
to search for flowers from the sky.
But all she saw were lawns stripped bare –
a world of concrete everywhere.

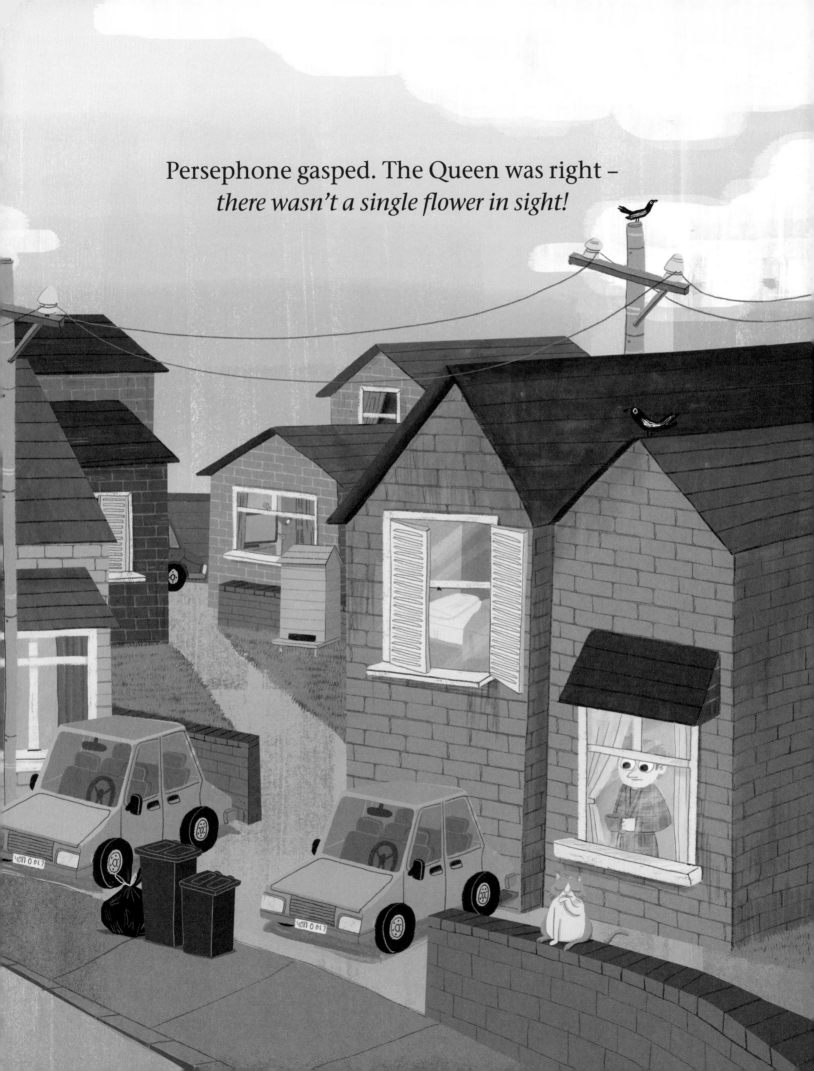

Persephone gasped. The Queen was right –
there wasn't a single flower in sight!

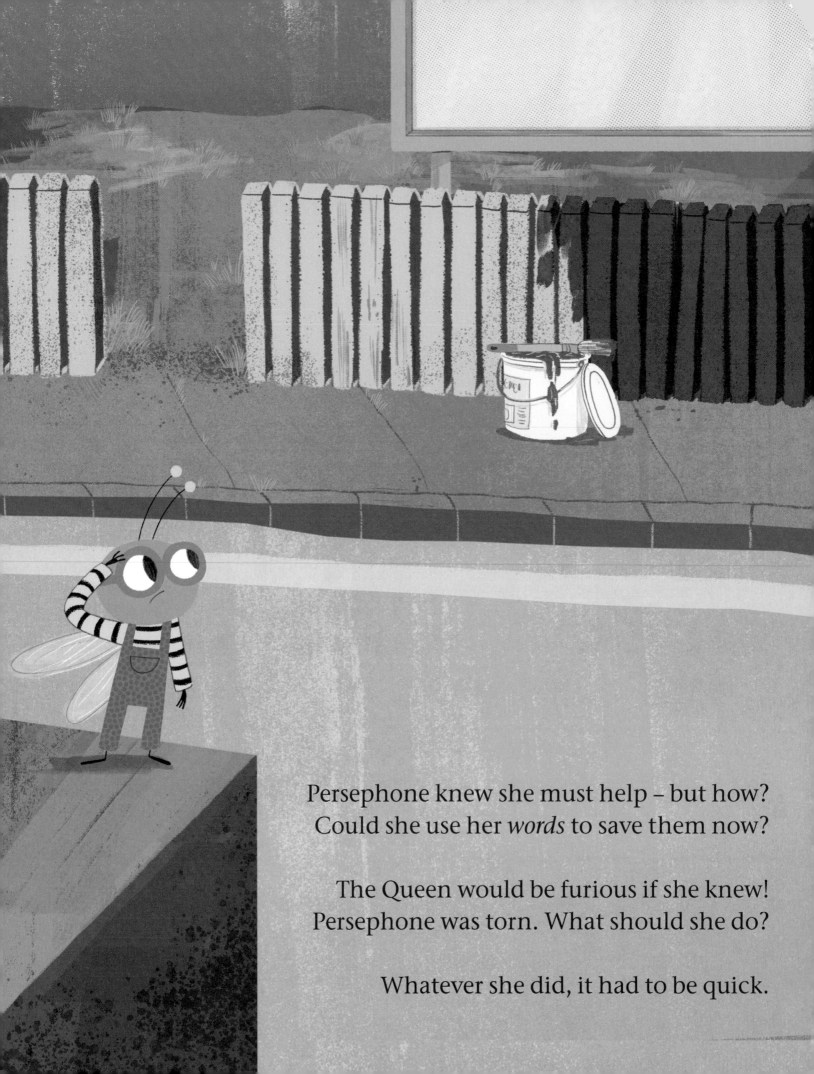

Persephone knew she must help – but how?
Could she use her *words* to save them now?

The Queen would be furious if she knew!
Persephone was torn. What should she do?

Whatever she did, it had to be quick.

Persephone grabbed some paint and a stick . . .

Job done, Persephone fled the scene –
she knew she'd disobeyed the Queen.

Her words were there for all to see . . .
but who would listen to a little bee?

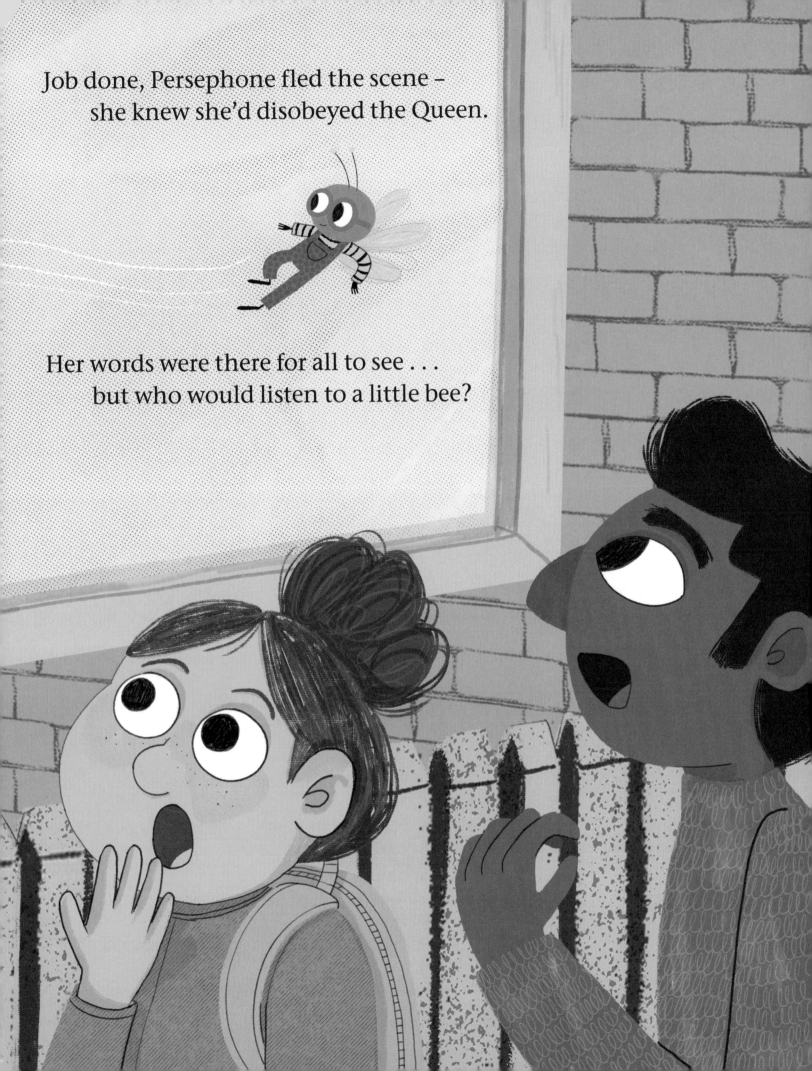

That day, people came and pulled up weeds.
They raked the ground
and they planted seeds.

As the flowers grew,
the bees all cheered . . .

But Persephone
had disappeared.

"It's weird!"

"She didn't say goodbye!"

Only the *Queen* knew the reason why.

Persephone crouched in her hiding place.
She didn't dare to show her face.

And there she stayed – until, at last,
a bright-winged butterfly fluttered past

To: Persephone
From:
Queen Hermione

with an envelope . . .
What could it be?

A letter from Queen Hermione!

Persephone, your words have saved us all.
Thank you for writing on the wall!

Now, please come home; I must insist.
Persephone, you are greatly missed.

From that day on, in every weather,
the bees kept working – all together –
to help protect the world they knew:
a world where trees and flowers grew.

And this was thanks to a very brave bee
with a very long name: Persephone.

She might be smaller than a flower,
but she showed us all that words have

POWER!